REALISM

D1333632

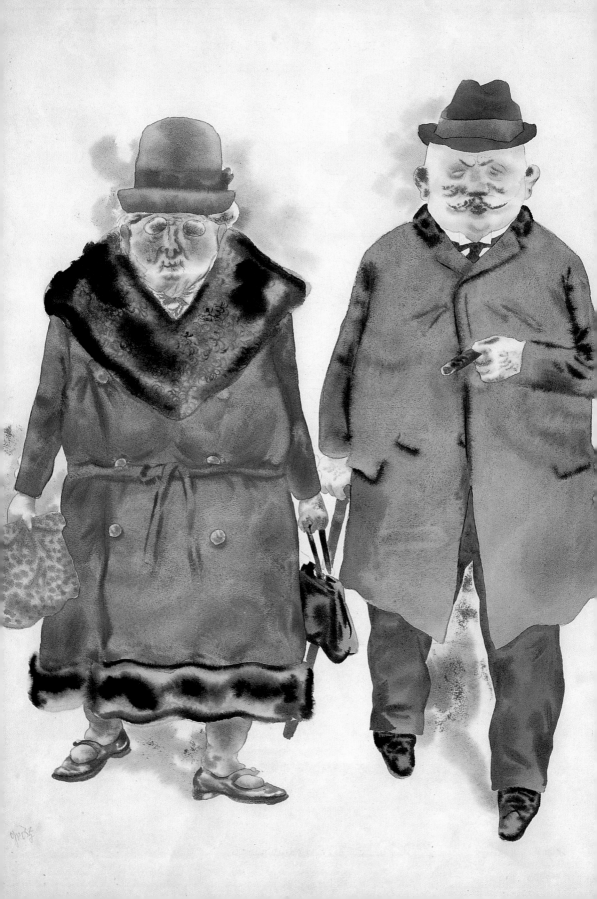

REALISM

JAMES MALPAS

TATE GALLERY PUBLISHING

Cover:
Stanley Spencer,
*The Resurrection,
Cookham* 1924–7
(fig.12)

Frontispiece:
Georg Grosz,
A Married Couple 1930
(fig.21)

ISBN 1 85473 186 X

A catalogue record
for this book is
available from the
British Library

Published by order
of the Trustees of
the Tate Gallery
by Tate Gallery
Publishing Ltd
Millbank, London
SW1P 4RG

Cover designed by
Slatter-Anderson,
London
Book designed by
Isambard Thomas

Printed in Hong
Kong by South Sea
International Press
Ltd

Measurements are
given in centimetres,
height before width,
followed by inches
in brackets

Contents

INTRODUCTION

Realism is in danger of becoming, to use Henry James's phrase, a 'baggy monster', spilling out into virtually every art movement and group since it came of age in the declarations and work of the Realist painter Gustave Courbet in France from the 1840s, and in the contemporaneous commitment of the Pre-Raphaelite Brotherhood in England to a return to nature. After all, no artist refers to their work as unreal, or anti-real. Indeed, even the most extreme abstract art has consistently been claimed by its practitioners as a form of realism: in 1920 the Russian Constructivist, Naum Gabo, published his *Realistic Manifesto*; in the early 1960s the New Realist group in France comfortably accommodated Yves Klein, known for his monochrome canvases. These artists stood the term realism on its head to make it mean an art which opposed the imitation of reality in order to establish itself as a new reality in its own right. This definition is a crucial cutting-off point for this book; for a work of art to be included here it has to have some perceptible root in the considerations, both of subject matter and technique, of the nineteenth-century exponents of Realism.

There are also areas of painting where realist subject matter is married to an Expressionist use of paint, loaded with emotional charge, as in much of the Kitchen Sink school in the Britain in the 1950s (John Bratby for example) and in the very painterly work of the British artists Frank Auerbach and Leon Kossoff, where realism seems to be abandoned rather than enhanced. (By contrast, Lucian Freud never goes into the same arena of gestural commitment in his brushwork, maintaining something of a Ruskinian

humility before the subject.) If one included such expressionistic gestural painters, one would also need to refer to Meidner, Soutine and de Kooning's majestic *Women* series, as well as earlier German Expressionism as a whole, which would widen the frame of reference so much as to make the term 'realist' almost meaningless in a book of this length.

It is impossible to ignore the relationship of photography to the realist tradition in painting and of course to modern art in general. Photography both provoked painters to become *less* realistic, to distance themselves from this rival, and gave them the means to become *more* realistic. In the latter case, their often unacknowledged use of the 'foe-to-graphic' art (Edwin Landseer's pun) shows how sensitive they were to accusations of plagiarism. However, photography, though an *eminence grise* of realism, needs far more extensive treatment than the scope of this book will allow; and there are many easily available histories of the subject (see Further Reading).

As a quality, realism is positive, denoting toughness, down to earth attitudes to life or death and a practical outlook on the way things should be managed. It also presupposes the need for management of, or at least of some measure of control by man over, the environment or his fellow human beings. The need for realism, in both life and art, may be the result of a sense that fantasy, imagination, speculation have all run away with human attention and that things as they are have been shunted into the area labelled 'ordinary, everyday, uninteresting'.

In relation to art, realism has the great advantage of ubiquitous subject matter. Anything that actually happens or exists is seen as worthy material. However, it is at the level of interpretation of those events and things that the interesting difficulties in defining realism appear.

In their response to things and events in the world, realists aim at a level of objectivity that 'romantics' abhor. Yet what is the nature of this objectivity? That proposed by Courbet in about 1849 is different from that simultaneously embraced by the Pre-Raphaelites, yet both could be accommodated under the realist umbrella.

Paradox underlies the approach of nearly all artists claiming to be 'realists' and this applies particularly to those in the twentieth century. Unlike Courbet, these artists do not usually establish a proselytising Realist stance, with defined aims. They are often individuals, defining themselves against the so-called progressive or avant-garde trends of the day, or indeed, simply ignoring them. The concept of an avant-garde, popularised by the critic Julius Meier-Graefe around 1910 to account for the successive waves of 'isms' in European art from the early nineteenth century, is in danger of skewing any assessment of art into the 'cutting edge' versus the 'has-beens'. Certainly, except for brief periods, the realist tendency has been relegated to the also-ran category throughout the twentieth century, by the cognoscenti, the major collectors, and often the avant-garde artists themselves.

Realism in the twentieth century, then, exhibits a protean stylistic and ideological approach. It can range from the passionate and quirky individualism of a Stanley Spencer to, contemporaneously, the most demoralised institutionalism of an 'apparatchik' painter like Alexander

Gerasimov in the Stalinist USSR, where it appears under the guise of 'socialist realism'. Any attempt to provide a cogent definition, as one can in the case of a relatively team-based, well-knit 'ism' such as Surrealism, will be thwarted at the start. For the most part, realism in the twentieth century is not 'Realism', that's to say, something consciously signed up for, via a manifesto, to show a party allegiance.

From its roots in the nineteenth century, Realism encompasses a bewildering range of styles: we now see Courbet and the Pre-Raphaelites equally as Realist painters, but their stylistic hallmarks and paint-handling are significantly different. And, whereas a Surrealist, having 'joined up', made more or less conscious efforts to ensure a correct Surrealist component in his work, no such compunction weighed on so-called 'realists', except in

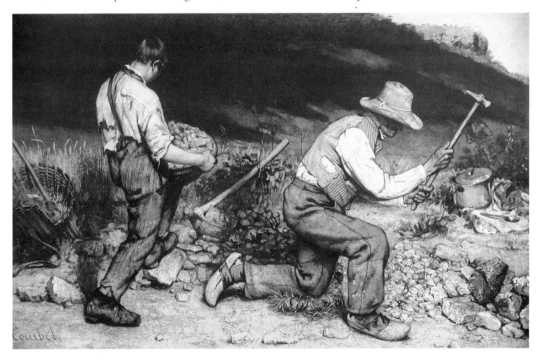

totalitarian states. For the realist, the saleability of a work might motivate the artist as much as any ideology. Realism in the twentieth century can thus be seen in terms of highly individual figures appearing almost at random. And yet there were periods when the tide of realism was flowing high, notably after the cataclysm of the 1914–18 Great War (see chapter 2) and to some extent after the Second World War.

Many interesting questions arise when considering realism in later twentieth-century art. How 'realist' is Pop Art? On one level its adherence to the trivial, the everyday, the trashy and throw-away is counter to Courbet's notion of contemporary heroism (let alone Pre-Raphaelite moralising). Yet at the same time this aspect corresponds to the realist idea that art can encompass the most humble and everyday subject matter, and Pop's heroes were often working class, like Courbet's.

I

1
Gustave Courbet

The Stonebreakers
1850

Oil on canvas
165 × 238
(65 × 93¾)
Stadtmuseum, Dresden
(destroyed 1945)

THE BEGINNINGS OF REALISM

It would be impossible to present the themes, concerns and works of realism in the twentieth century without some consideration of 'Realism', the art movement that developed from the prevailing Romanticism of the 1830s in France and which, by the mid-century, had gained adherents in England as well. In 1798 the arch-romantic philosopher-poet Friedrich von Hardenberg (known as Novalis) had begun his book of aphorisms: 'We seek above all the Absolute, and always find only things'. That 'only' is the quintessence of Romantic disappointment with the merely material. If one reverses the dictum, however, so that 'things' become the goal of the search, something of the Realist approach can be seen. Certainly, Courbet, the painter- spokesman for Realism, was determined that 'things as they are' should be the subject of painting.

At the time – the 1840s – they weren't. A few artists, such as Valenciennes, had unselfconsciously produced sketches (still marvels of freshness today) that had challenged the academic standards of 'composition' and 'finish'; but these were 'mere' sketches. Courbet was determined that the rules and regulations of the ateliers and the Academy, which had become so much more strict since J.-L. David's virtual dictatorship on behalf of Neoclassicism at the time of the French Revolution, should be set aside. Gustave Courbet proposed that instead of a history subject, or the moral, sentiment or 'story' of the painting dictating how it should look, as was nineteenth-century academic practice, the painter should let things and their appearance stand for themselves. This is what Courbet did in *Burial at Ornans* (fig.2), which

shocked conservative critics at the Salon of 1851 and baffled even the liberal-minded. They did not understand what the 'subject' was; was it the hole in the ground? How could that be a serious subject for a huge painting intended for the Salon, the prestigious annual show? Was Courbet simply laughing at them? (Certainly, we shall see a satiric or at least ironic edge as a major feature of realism in the twentieth century.) And the people! What a strange bunch of village misfits! Yet they were not caricatures in the way Daumier would

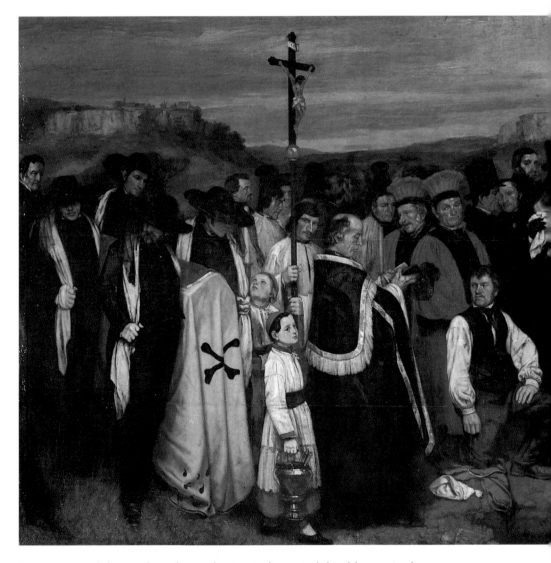

have portrayed them. The red-nosed priest is shown indubitably to exist, by virtue of the very care that Courbet has taken to record his idiosyncrasies. The effect was startling: the clumsy procession shows none of the professional grace of learned poses, derived from tradition, that the gallery-goers would have expected.

Realism here lies as much as anywhere in the dovetailed awkwardness of the figures as they plod across the picture-space, the very subtle rhythm of

2
Gustave Courbet

Burial at Ornans
1849–50

Oil on canvas
314 × 665
(123½ × 261¼)
Musée d'Orsay

design that Courbet uses to link up the trudging group. This rhythm does all it can not to attract attention to itself, whereas the average Salon piece would ostentatiously display the artist's skill at manipulating stock figures into a traditional academic format, so as to prove that the work had been done according to the rules.

This was the challenge Courbet threw at his contemporaries: that rules were to be provisional and not permanent fixtures. This was the first sign of a

pluralism in painting – whereby the appropriate technique, and style even, was more important than the academic hierarchy of subject. In France, at any rate, this would lead to the concept of a modern, avant-garde development from Courbet (and even Delacroix as far as colour was concerned) through to Seurat and beyond. In short, the avant-garde was that band of artists for whom how a painting was done became increasingly more important than the ostensible subject. By the First World War, the development of abstract, non-

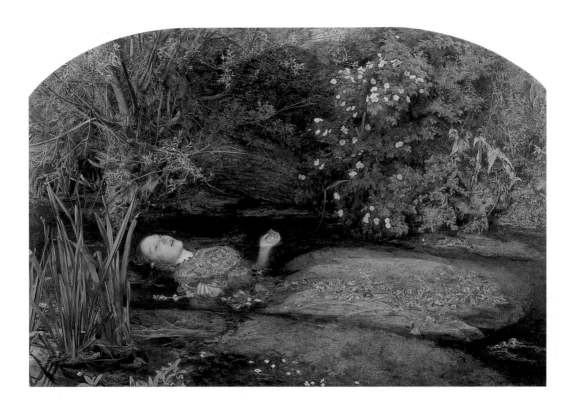

representational painting, would mean that the 'how' of the painting *was* the subject.

Meanwhile, painters adopted and adapted the themes and theories that Courbet proposed throughout a tumultuous career. This ended in despondency and illness in exile in Switzerland in the 1870s and death in 1877. It should also be remembered that not all his work was as pictorially challenging as the *Burial at Ornans* and he could churn out effectively conservative landscapes full of 'nature-philosophy' feeling for bourgeois German clients. But around Courbet's banner in the early 1850s swarmed artists as diverse as the peasant-painter Jean-François Millet, and the brilliant and vituperative cartoonist and illustrator Honoré Daumier, as well as a number of minor figures who had produced one or two Realist works, but found the negative publicity or the close contact with their subjects too gruelling and so moved into more lucrative and easy-going avenues. One might cite Jean-Pierre Antigna, whose *Fire* was shown at the same Salon as the *Burial at Ornans*: a peasant family is shocked by the outbreak of fire in their small cottage. The pose of the mother and child seems to be a cunning adaptation of Delacroix's *Medea* (1838), a classically based, High Art subject here transformed to suggest similar courage and fortitude in the lower orders. It was an appropriate theme during the short-lived Second Republic of 1848–52.

In England at the same time but from a very different direction came another impulse towards realism in painting. Again, the academic was the butt

3
John Everett Millais

Ophelia 1851–2

Oil on canvas
76.2 × 111.8
(30 × 44)
Tate Gallery

4
Robert Martineau

The Last Day in the Old Home 1862

Oil on canvas
107.3 × 144.8
(42¼ × 57)
Tate Gallery

of the attack by various young turks who (rightly) saw that the formulaic conventionalities hung at the Royal Academy every year were stultifying. However, social concerns of the kind revealed in Courbet's depictions of real people hardly impinged on John Everett Millais (though his image of a fireman rescuing children of 1853 makes an interesting comparison with the Antigna), William Holman Hunt and Dante Gabriel Rossetti, the ring-leaders of the Pre-Raphaelites. The name itself shows just how disaffected with contemporary art they were. Their realism consisted partly in their doctrine of painting every element in a picture meticulously from life. In doing this they sometimes achieved an illusionism which is almost hallucinatory. Luckily, the subjects themselves were often hallucinatory as well, as in the case of Millais' popular painting of mad Ophelia (1853) for example. *Ophelia* is typical of the largely historical and literary subject matter of the Pre-Raphaelites which ranged from the Bible, Dante and Shakespeare through to Romantic poetry, particularly that of Tennyson who, though contemporaneous, wrote in a pseudo-medieval style. In painting such subjects Pre-Raphaelite realism also consisted in reconstructing the scene with as much historical and psychological accuracy as possible. There are a few Pre-Raphaelite modern life paintings, for example Holman Hunt's topical blow against masculine sexual hypocrisy *The Awakening Conscience*, also of 1853, where the detail is used to construct a moral allegory, and Rossetti's significantly unfinished *Found*, where the evil of prostitution is likewise the subject.

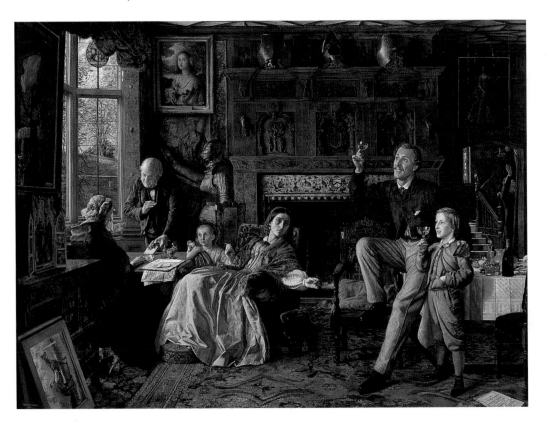

Bright colours, detailed still-life and the use of new chemical and aniline colours from Germany marked off these young artists from the generality at the Royal Academy. By 1860 however, many of the latter were following suit, and though they could not match the perfervid imagination of the original Pre-Raphaelites, they managed to produce works as equally loaded with material detail (easy enough with Victorian furnishings of the time). R.B. Martineau's *The Last Day in the Old Home*, a product of ten years' work, is a good example. Again, the strength of detail is used to point to the moral and adorn the tale.

A rather different form of social realism appeared in England during the 1870s. Its chief exponents were Luke Fildes, Hubert von Herkomer and Frank Holl and it can be related to Millet's 1848–53 depictions of peasants in

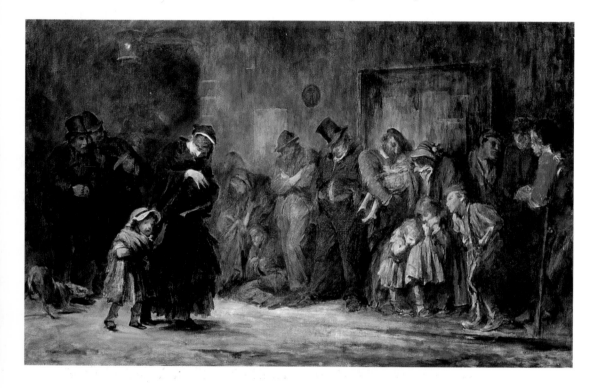

the fields of France or Courbet's *The Stonebreakers*, of which he declared: 'I have invented nothing. I saw the wretched people in this picture every day as I went on my walks'. A celebrated example of the British realism of the 1870s is Luke Fildes's very popular Royal Academy exhibit *Applicants for Admission to a Casual Ward* of 1874 (of which the illustrated version is a replica from after 1908), which has all the descriptive pull of a Dickens narrative as it presents the parlous state of the urban poor in the city snow. It looks melodramatic set against the Courbet *Burial*, but in comparison with other Academy works of the time it is rough and blunt in its sympathies.

Another English realist style popular in the 1880s particularly, derived from topographical painting. Atkinson Grimshaw's moody, atmospheric nocturnal scenes, with tonal subtleties and flickering chiaroscuro that seem to

owe as much to photography as to painting are good representatives of this trend. Close to these, though more concerned with social subjects and the figure, is the elegant artist James Tissot, who called himself a 'realist'. Certainly, he takes a cool gaze at the folk in their finery who are generally at leisure in his opulent work.

His generally upper-middle class subject-matter (the exception is soldiery, but then their tunics are so bright and cheery) could be contrasted with the products of Jules Bastien-Lepage's English followers, from the mid-1880s onwards. This French artist (1848–1884) specialised in chic peasant children posing artlessly close up to the picture plane – photography was very much an influence. In 1882 he visited London and thereafter a clique adopted his

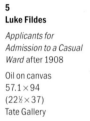

5
Luke Fildes

Applicants for Admission to a Casual Ward after 1908

Oil on canvas
57.1 × 94
(22½ × 37)
Tate Gallery

6
George Clausen

Winter Work 1883–4

Oil on canvas
77.5 × 92.1
(30½ × 36¼)
Tate Gallery

block-like use of paint, with the use of square-tipped brushes, the neutral grey-blue palette and the winsome models that make Murillo's peasant children look louche by comparison. George Clausen is an important follower of Bastien-Lepage and there is a trace of social comment in his *Winter Work* of 1883–4 as the warm gallery-goer is confronted with the mangold-grubbing field workers with frozen fingers.

2

7
Walter Richard Sickert
La Hollandaise c. 1906
Oil on canvas
51.1 × 40.6
(20¼ × 16)
Tate Gallery

REALIST PAINTING IN ENGLAND 1900–1940

In the years before and during the First World War realism in England has to be seen in the context of a belated catching up with the continental avant-garde. The zeal and polemical energy of the Vorticist movement reached an apogee of non-representational painting around 1914, with Edward Wadsworth, Frederick Etchells and William Roberts joining Wyndham Lewis and others in what Alan Bennett calls the 'jagged school' of English painting. Ironically, the style is best exemplified by Bomberg's massive *In The Hold*; he wasn't officially in the movement.

Less extreme was the art associated with Roger Fry and the Bloomsbury circle. Fry's two Post-Impressionist exhibitions of 1910 and 1912 certainly surprised – and in the case of conservatives, dismayed – the viewers, leading Virginia Woolf to note portentously later, 'On or about December 1910 human nature changed'. Sir Philip Burne-Jones, the famous Pre-Raphaelite's painter son, fulminated against Cézanne, declaring him 'mad', and such a response was typical of academicians as a whole.

However, a third area of the avant-garde, the Camden Town Group, had been assiduously applying Post-Impressionist techniques for several years, but to realist subjects. This development was given a fresh and dynamic twist by Walter Sickert in the new, grainy subject-matter that erupted around 1907. His *Camden Town Murder* series has a bleak tawdriness about it that is completely unidealistic.

He claimed that newspaper reports of gruesome murders of prostitutes had prompted the title, and this attraction to reportage would always haunt

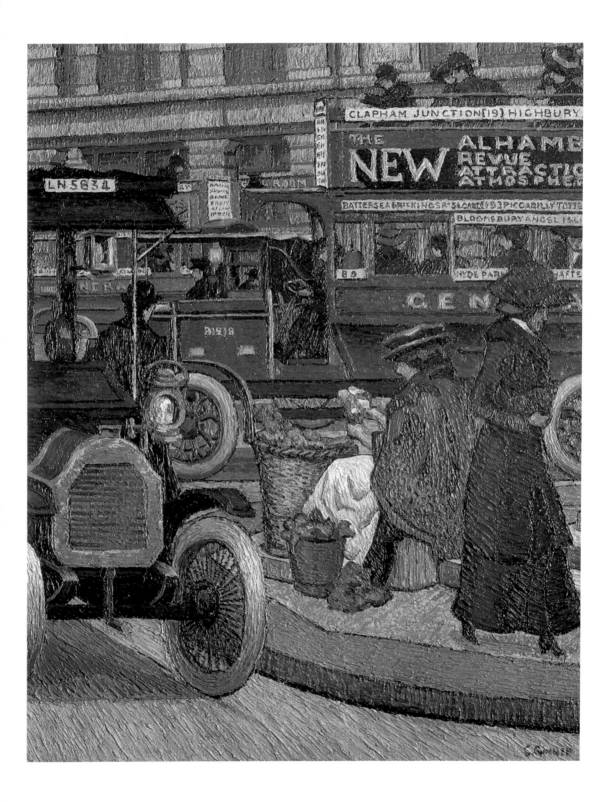

Sickert. Certainly the cadaver-like appearance of the flaccid models on rented beds deviated wildly from the decorous poses of drawing-school life models. Such works derive in part from Cézanne's gruesome portrayals of sex-murders, probably inspired by Emile Zola. Sickert's flat, attenuated brushstrokes, as if he too were stabbing at the figure, and the bald, often muddy colouring, would have seemed repellent even to those used to the cursory brushwork of the other Camden Town artists like Charles Ginner, Harold Gilman and Spencer Gore.

This is a case of realistic subject-matter being treated in an unconventional painterly manner, and it would characterise much of what passed for realism in England between the wars. Sickert's flat, almost distemper-like blocks of paint adapt imagery culled from newspapers, whether of Amelia Earhart's arrival in rainy Britain after a record-breaking air flight, or a snap-shot portrayal of a uniformed Edward, Prince of Wales, striding from a car. There is still much critical division as to the merits of such work, but it is remarkable how Sickert kept on experimenting with such approaches until the end of his long life.

8
Charles Ginner

Picadilly Circus 1912

Oil on canvas
81.3 × 66
(32 x26)
Tate Gallery

9
Walter Richard Sickert

Miss Earhart's Arrival
1932

Oil on canvas
71.7 × 183.2
(28 × 72¼)
Tate Gallery

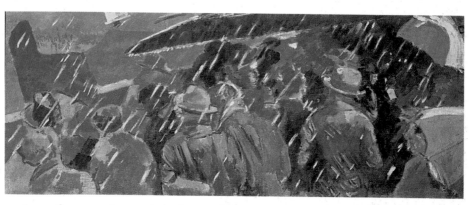

Apart from two images in early 1914 Sickert was not directly involved in depicting the Great War. The profound change that came over war-weary Britain by 1916, when conscription was established, made the dynamic and generally optimistic energy of the Vorticists seem jejune, if not downright tasteless. What energy there was became converted to the mission of showing the civilians just how appalling the conditions were at the Front, just ninety miles from London. As Paul Nash wrote: 'It is unspeakable, godless, hopeless. I am no longer an artist interested and curious, I am a messenger who will bring back word from the men who are fighting to those who want the war to go on forever. Feeble, inarticulate, will be my message, but it will have a bitter truth.' In fact, by 1918, Nash's work was anything but 'feeble' or 'inarticulate', especially in the way it envisaged the destruction of the natural order.

Officially, there was no call to do other than record the scenes met with, though there was a certain amount of censorship. William Orpen was occasionally criticised for the sunny landscapes he depicted, the only dead being German. His employers at the War Office wanted something more arresting. Ironically, when they got it in the increasingly dour imagery of Christopher Nevinson they were equally dissatisfied. The bleak swampish

battlefields on which dead British lie, which Nevinson was producing by 1917, such as the sardonically titled *Paths of Glory*, were censored by the authorities as bad for morale. By contrast, his lithographs of aerial combat, clean and thrilling, found great favour. This determination of many artist-participants to show the civilians 'just what it was like' did produce an astonishing work in Sargent's *Gassed* of 1918, in which the irony of the bright summer sunlight of the last few weeks of the war, unseen by the frieze of blinded 'Tommies' in mud- and blood-stained khaki, is inescapable.

Even Wyndham Lewis found his abstract energies displaced by the contingencies of war. His most famous full-size painting on the theme is *A Battery Shelled* of 1919, in which some supercilious officers, one smoking a pipe, observe the ant-like soldiers scurrying about as enemy shells land among their guns. The smoke looks like ribbons of twisted metal. It can be contrasted with the more tangibly smoke-like substance the Turkish shells are producing amidst the Irish troops encamped in the Judaean hills depicted by Henry

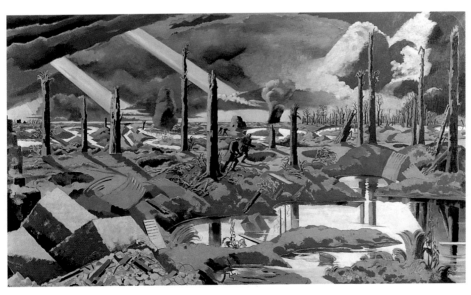

10
Paul Nash

The Menin Road 1919

Oil on canvas
182.8 × 317.5
(72 × 125)
Imperial War Museum,
London

11
John Singer Sargent

Gassed 1918

Oil on canvas
228.6 × 609.6
(90 × 240)
Imperial War Museum,
London

Lamb, generally better known as portraitist of a limp and effete-looking Lytton Strachey, noted essayist and pacifist. The realism of Lamb's war-picture is tempered by the fact that it was incomplete at war's end and the 'Irish' were in fact models found in Camden in 1918–19. This artist and his fellow Slade school contemporary, Stanley Spencer, had both been impressed by the Italian early Renaissance artists from Giotto and his pupils through to Massacio, Masolino and Fra Angelico in the fifteenth century. Their clarity of line, the subordination of anatomical or perspective accuracy to emotional charge, allowed Spencer and Lamb to escape from the rigours of the Slade's academic teaching.

Spencer's realism is a vivid hybrid, combining this early Renaissance manner with echoes of William Blake and Samuel Palmer, where medieval overtones persist in form and colour. Its power first makes itself felt in the haunting 1914 work, *The Centurion's Servant*, with its awkward positioning of

the body on the bed, perhaps reminiscent of Sickert's Camden Town nudes, and the stricken expression on the face. Is it a reworking of Holman Hunt's *The Awakening Conscience*? Certainly Spencer seems to be trying to depict an inner state of struggle that goes far beyond the melodramatic or theatrical. Spencer's involvement in the war, on the home front and then in Macedonia, was less traumatic for him than for many others, though not without its alarms and excursions. In fact, he seems to have been brought out of himself, made to interact with humanity, which liberated his pictorial vision. By the time he produced *Arrival of the Travoys*, his great, immediate record of his time as a medical orderly in Macedonia, the constraint visible in his early work had gone. As is common among the artists influenced by the early Renaissance, he takes a high viewpoint, and this foreshortens the arriving ambulances wildly; but the gestures of the orderlies and the amiable gaucheness of the mules (which *are* pink in Macedonia) show a flair for realistic observation. The same spirit later infused his panels for the Sandham Memorial Chapel at Burghclere, completed in 1932, where his humorous recollection of army

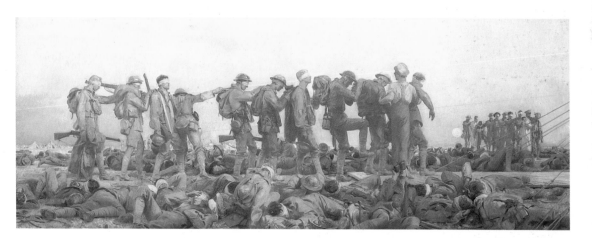

camp-duty portrays a scampish Spencer, like a scruffy schoolboy, stabbing litter with a bayonet. He was once on a charge for 'picking up litter in an unmilitary manner'. Local colour is represented by English summer flowers depicted with the intensity of Samuel Palmer and, out in Macedonia, the native tortoises shuffling about.

Spencer's grandiose *The Resurrection, Cookham* (1924–7) is a fine example of his ability to combine natural and illusionistic elements to produce something rich and strange. The artist appears several times in the work, as does his wife. Other Cookham notables are shrewdly and humorously portrayed emerging from their lopsided graves in the village churchyard. A more universalist theme is stressed by the black people also emerging at the centre of the work. As in medieval or early Renaissance religious works, sequential events are depicted happening simultaneously.

Spencer's sense of realism was rooted in the religious significance he felt was inherent in ordinary activity. William Blake believed 'everything that lives is Holy!' and something of this view can be seen in Spencer's *Resurrection*, best

described by the term 'magic realism'. No doubt the Renaissance basis of his art, rather than the emotional uncertainties at the root of, for example, German Expressionism accounts for this.

In the Second World War, Spencer produced an emphatic and energised series of canvases showing the war-driven ship-building on the Clyde. Again, his fundamental interest in humanity enabled him to mix and merge with the workforce and, as his diaries show, he found himself moved and fascinated by this very different world. The works themselves are occasionally prey to fervid distortions, not helped by the strange format he was working with, but the

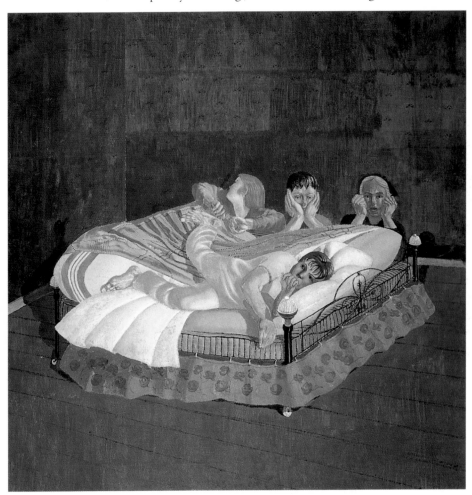

12
Stanley Spencer

The Centurion's Servant
1914

Oil on canvas
114.3 × 114.3
(45 × 45)
Tate Gallery

13
Stanley Spencer

*The Resurrection,
Cookham* 1924–7

Oil on canvas
274.3 × 548.6
(108 × 216)
Tate Gallery

extraordinarily sacerdotal effect – as if Giotto spent the 1940s in a shipyard – gives the realism Spencer deploys a memorable resonance.

Much British art in the 1920s was vitiated by trying to ape Matisse's Fauve work of around 1905–8. Such pastiches corrupt the work of Mark Gertler, while the vivid Fauve palette produces some oddities in the work of Matthew Smith. With hindsight, it can be suggested that Roger Fry and Clive Bell's hijacking of the aesthetic bandwagon in British art around 1910 (an activity so scathingly attacked by Wyndham Lewis) with 'significant form' as their catchword, was as much an aberration from British concerns with detail,

decoration and surface pattern, as French Romanticism went against the grain of that nation's fascination with logic. From that viewpoint, the return to favour in the 1960s of the Pre-Raphaelites and other Victorian artists was a foregone conclusion, despite the Bloomsbury group's condemnation that had them swept out of the galleries for fifty years.

The Anglo-Saxon world (the United States even more than Britain) is fascinated by things, not ideas. A painting is a gadget, just as a story is; both have to be 'well-made', regardless of any philosophy they may contain. But where Roger Fry wanted the significance of the form to count, the British preferred to stay with the forms themselves. Perhaps that is why British sculpture is so powerful and why a painter like Ben Nicholson is most admired for his sculptural white reliefs. Certainly, realism has never been demoted to the second rank in Britain this century in the way it has on the Continent and abstract art has never gained such a hold. However, the

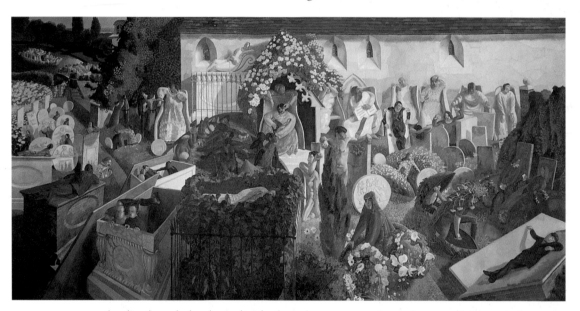

'realists' tended to be individuals and even eccentrics, at least until the period of Pop Art. The figure of Edward Burra is a fascinating example of someone who pre-empted Pop in some ways, lived through it, and emerged as though nothing had happened.

Ironically, Burra was one of the most cosmopolitan young British artists of the 1920s, travelling to the South of France, where Cocteau's charmed life appealed to the dramatic flair of the young Englishman, as did the raffish life in downtown Marseille and Toulon. America, and jazz (as experienced in Harlem in the late 1920s) toughened up his style. Laconic, drawling humour and sharp, snarly observation of the low-life around him give an atmosphere akin to an exotic Georg Grosz (see p.32). Burra was never bitter, however; instead, a cartoon-book brashness and wide-eyed amazement predominates, a quality he was to recapture in the late 1960s when his work took on a hippy-like abandonment. Accusations that his work is simply eclectic, shallow illustration can be countered by his grim and mordant paintings of the late

1930s. In England during the war, he produced sardonic grotesqueries depicting soldiers stationed in the Kentish town of Rye where he lived at the time. Humanoids, rather than humans, they relate to the demonic figures Wyndham Lewis produced in the 1920s. Gentler veins of narrative landscape emerge after the war in Burra's radiant watercolours, though the sardonic edge is never far away: in *Lake District* of 1970 the view is obscured by the traffic thundering past.

Burra is an elusive artist to assess in terms of realism, as are Grosz and the angrier Weimar German artists. Emotional values are of central importance to all of them, but such values have their own reality as equally as the apparently rational ones of *Valori Plastici* (see p.40) and its neo-classicism. Stanley Spencer's great achievement in his greatest works was to 'square the circle' so that the emotional and the rational cohabit.

After the First World War the Vorticist William Roberts turned to

realism, as did so many of the pre-war avant-garde. In *Self-Portrait Wearing a Cap* Roberts depicts himself in a shirt, wearing braces, tie and flat cap. He thus identified himself as a working man, a persona he projected in later self-portraits of the 1950s and 1960s.

In the early 1930s there was a resurgence of avant-garde activity in British art. Two groups strongly concerned with abstraction emerged, the Seven and Five Abstract Group and Unit One, both with links to the Paris based Abstraction-Création group. The influence of Surrealism was also strong, reaching a climax in the International Surrealist Exhibition in London in 1936. Towards the end of the 1930s something of a reaction seems to have taken place and was most visible in the group of artists known as the Euston Road School, from the school of art of that name founded in London in 1937 by Victor Pasmore, Claude Rogers and William Coldstream. Influenced in their political and social attitudes by the harsh economic climate of the 1930s

these artists adopted realism in the hope of bringing art to a wider audience than was reached by the avant-garde. They laid particular emphasis on painting from observation, and in subject matter they favoured scenes of everyday London life, and the nude, in much the same way as had Sickert and the Camden Town painters earlier in the century.

14 *left*
Edward Burra

Soldiers at Rye 1941

Gouache, watercolour
and ink wash on paper
102.2 × 207
(40½ × 81½)
Tate Gallery

15
William Roberts

*Self-Portrait Wearing
a Cap* 1931

Oil on canvas
55.9 × 35.9
(22 × 14¼)
Tate Gallery

16 *far right*
William Coldstream

Seated Nude 1951–2

Oil on canvas
106.7 × 70.7
(42 × 28)
Tate Gallery

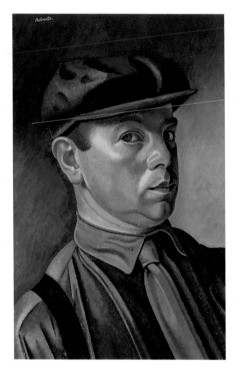

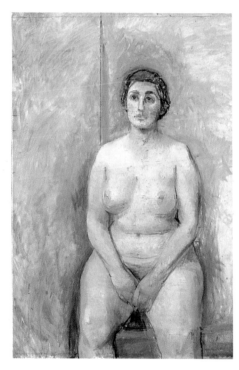

3

REALISM BETWEEN THE WARS

The exhaustion of the combatant nations in the Great War and the moral and financial bankruptcy that threatened them after the November 1918 Armistice combined to make the world of the 1920s an unfruitful place for many of the Utopian, transformational aims and goals with which art – particularly non-representational art – had been preoccupied before 1914. Instead, there was a gathering together of depleted forces and a 'call to order'. This phrase, the title of a book published by Jean Cocteau in 1926, became the catchphrase of the decade, even if order was hard to locate, or, as in Italy from 1922 , Russia from 1924 and Germany from 1933, to separate from a state-sponsored rule of terror. In comparison with the late nineteenth century, a new diversity of what was thought to constitute realism appears, a mirror to the fracturing social and political structure at this time.

In particular, realism between the wars needs to be seen in the context of the alternative definition of realism put forward by the avant-garde (see introduction). For example, while the artists who were grouped together in 1920s Germany under the banner of the New Objectivity (Neue Sachlichkeit) are evidently more traditional, more realist, than the non-representational artists of the Bauhaus such as Paul Klee and Wassily Kandinsky, at the same time the latter would argue that mechanically produced, geometrically based two-dimensional and non-illusionistic works are more realistic in themselves and in relation to modern society than the academic illusionism that was still at the core of figurative art. This new concept of reality in art was even more fervently pursued in post-

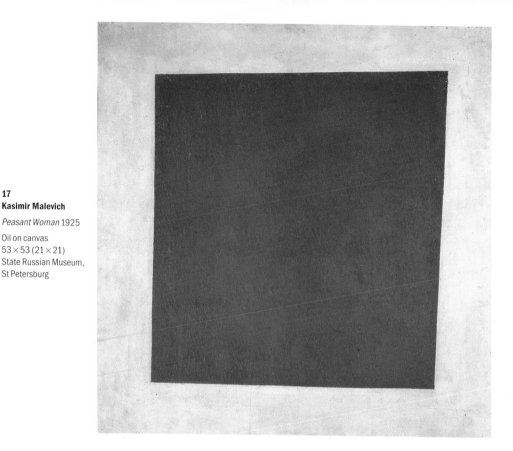

17
Kasimir Malevich

Peasant Woman 1925

Oil on canvas
53 × 53 (21 × 21)
State Russian Museum,
St Petersburg

Revolutionary Russia by the Suprematists and Constructivists, though it was
to fall foul of the political authorities by 1922.

Russia

In about 1915–16, the Russian painter Kasimir Malevich titled one of his
Suprematist abstract works *Peasant Woman*, her red dress signified by the red
square that dominated the canvas. This cocks a snook at the literal-minded,
but whoever said that that state of mind was a realist one? Clearly Malevich
took the opposite view and this may largely explain why he stayed on in
Russia to fight his corner against the encroachments of state-administered
Socialist Realism. As for many of his like-minded contemporaries, it was to
be a lonely struggle, involving exile from positions of power and authority
(which he had held at the time of the Revolution). Nevertheless, visual
evidence of his combining of illusionistic realism with the avant-garde
variety of his Suprematist works is to be found in such late works as his
portrait of his wife of 1933. Her gnarled worker's hands, in sharply observed
textural three dimensionality, contrast vividly with the bright, flattened areas
of colour that denote the dress and collar she wears. It is a marvellous, coded
criticism of the bludgeoning political-aesthetic policy pursued by Stalin and
his cultural henchman Zhdanov.

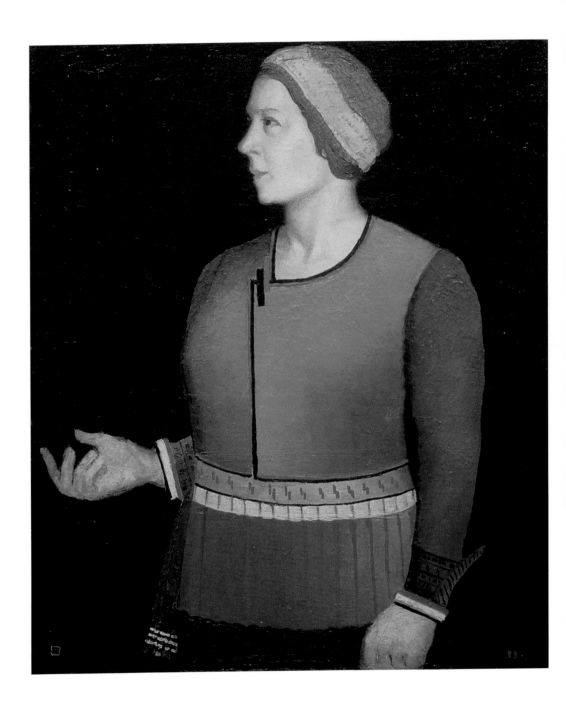

They proposed that only obvious transcriptions of the life of the people should be provided by artists, as anything else would not be understood. The word used to condemn intellectual or conceptually based art was 'formalist'. Even social realism in a Russian variant of French late nineteenth-century practice was not sufficient; it smacked too much of liberal individualism. Instead, a new cultural ethos of collective, group activity, geared to the glorification of the great Soviet state, was to be pursued, heroicising (rather than idealising – an important distinction between Communist State art and its non-identical Fascist twin) workers, peasants and the Motherland. The only individual as such was the father of the people himself, but none of the paintings of Stalin reveal more than an apparatchik, a supreme party factotum, an emblem of state. No psychology is allowed to intrude, hardly surprisingly, since artists whose portraits displeased the great aesthetician were liable for Siberia, or even in one case, shooting.

In this context, the subtlety of Malevich's handling of paint and image in the portrait of his wife is masterly, though largely wasted on the purblind authorities. Far more than any of the pasty, poster-like portraits of Stalin by academic creatures of the state arts apparatus, Malevich's work commits two crimes, not against art, but the aesthetics of the Soviet totalitarian state: the flat areas of paint denoting cloth are definitely 'formalist', that is, can be read as paint before being read as the material they are supposed to denote, and the individual psychology of the sitter is also conveyed. Other Russian artists achieved this latter feature, but never attempted the former as well. Perhaps Malevich's lonely position deserves the name of 'anti-socialist realism'?

Certainly, Malevich and a number of followers had seen their Suprematist ideas and works as examples of a new realism for the modern age, an art appropriate to the new Utopias devised by avant-garde artists in the wake of the political revolution (and which they had been thinking about for many years before). The schism in Russian art came between those who felt that such realism in art was sufficient in itself, and those who took the view that art should be subservient to the needs and goals of the Revolution. It is no surprise that as the Bolshevik position strengthened, it opted for the latter approach. Numerous artists went along with it. Others, like Naum Gabo and Kandinsky, fled. Perhaps the outstanding symbol of the short-lived combination of avant-garde 'realist' art and the real world is the agitprop train, bearing graphic propaganda through the countryside in an attempt to educate barely literate peasantry. It is perhaps a parallel to the 'dazzle-painting' camouflage on First World War ships by Edward Wadsworth, designed to protect Atlantic convoys against submarine attack. Paradoxically, in each case, abstract art is more useful than 'realistic' illusionism would be.

18
Kasimir Malevich

Portrait of the Artist's Wife 1933

Oil on canvas
67.5 × 56 (26½ × 22)
State Russian Museum,
St Petersburg

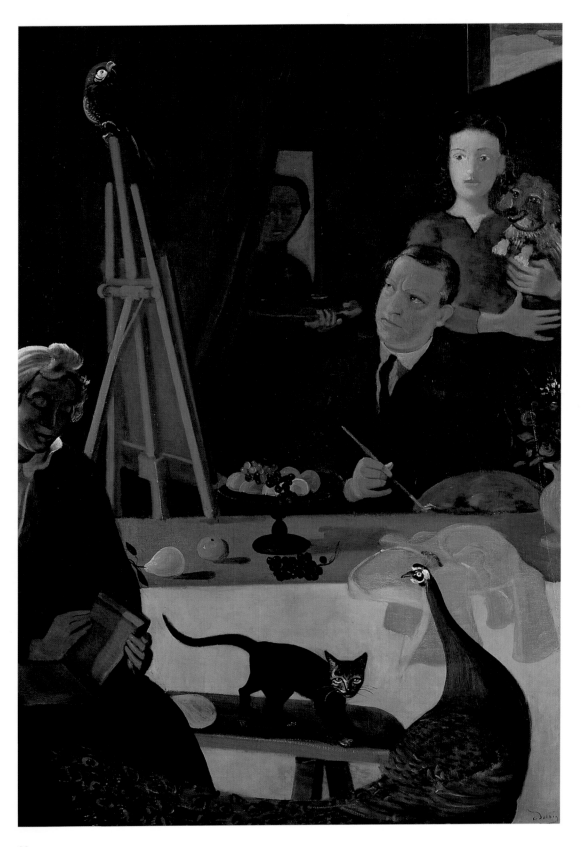

FRANCE

Meanwhile, in France the 'call to order' was manifest right across the
spectrum of the pre-war avant-garde: Picasso entered his neo-classical phase,
Matisse painted odalisques in seclusion in the south of France. But a return
to realism was most apparent and most focused in the work and thought of
André Derain, a leading member of the avant-garde Fauve group before the
war. Derain became a central and influential figure in the current of theory
and practice of painting in France between the wars which is sometimes
referred to as *traditionisme*. Derain believed that art was timeless and that its
function was to reveal meaning through elements of the real world that had,

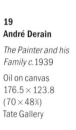

19
André Derain

*The Painter and his
Family c.*1939

Oil on canvas
176.5 × 123.8
(70 × 48¾)
Tate Gallery

20
Balthus

Sleeping Girl 1943

Oil on board
79.7 × 98.4
(31½ × 38¾)
Tate Gallery

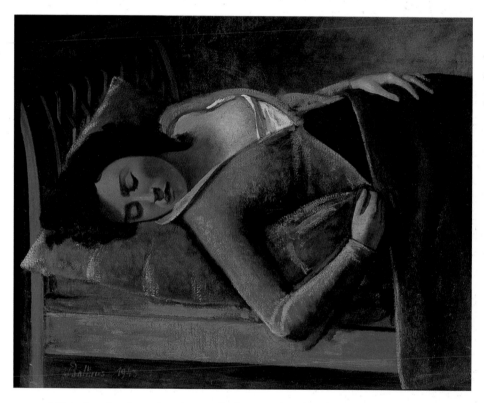

or could be given by the painter, a symbolic significance. *The Painter and his
Family* is an allegory of the life of the artist which pays an almost direct
homage to Courbet's own celebrated painting of his studio. Derain
particularly admired seventeeth-century painting and this work has echoes of
religious pictures of that period. The artist is at his easel surrounded by his
family, one of whom brings refreshments. His wife, his muse, reads – a
reference to the artist's literary interests, an integral part of his art.

In Paris in 1934 the first solo exhibition took place of one of the most
remarkable of all twentieth-century realist painters, Balthus Klossowski de
Rola, known simply as Balthus. Courbet is probably Balthus's single most
important point of reference in the art of the past, although, like Derain, he
looks also to the seventeenth century and beyond that to the early

Renaissance and the frescoes of Piero della Francesca. From the 1970s to the present his principal theme has been a haunting vision of the life of young women. Based on sketches from life his paintings are then painstakingly composed, often taking on an almost visionary quality while nevertheless remaining firmly rooted in the visible world.

NEUE SACHLICHKEIT: REALIST PAINTING IN THE WEIMAR REPUBLIC

In Germany the Neue Sachlichkeit or New Objectivity was a remarkably self-conscious stylistic development, responding to the collapse of Expressionism's subjective pathos and emotionalism in the wake of defeat in the First World War. There was a need for the ordinary to be reinstated. As Wieland Schmied, an authority on the subject, put it:

21
Georg Grosz

A Married Couple 1930

Watercolour on paper
66 × 47.3
(26 × 18¾)
Tate Gallery

22
Georg Scholz

Small Town by Day:
The Butcher 1922–3

Watercolour and pencil
on paper
31 × 24
(12¼ × 9½)
Staatlichen Kunsthalle
Karlsruhe

> The important thing was to focus one's gaze upon the here-and-now, upon the view out of the window, upon everyday life taking place in front of one's house, upon the alleyways and gutters, upon the factory floor and the shipyard, upon the scene in the operating theatre and the brothel – even if it should sometimes fall upon someone's allotment, or on a level-crossing keeper's hut, or on happiness in the corner.

This view was endemic throughout Europe in the early 1920s, but despite the general chaos of the Weimar Republic, it found almost its first organised artistic expression in Germany. Only the Italian magazine *Valori Plastici* signalled an earlier emergence of it. As early as 1922 a survey by the Berlin art magazine *Das Kunstblatt* enquired 'Is there a new Naturalism?'. The critic Franz Roh, in his 1925 book *Post-Expressionism, Magic Realism*, answered yes. The latter term fitted a number of fantastic and illusionistic works, sometimes labelled 'poor man's Surrealism'.

In 1923, the director of the Karlsruhe Kunsthalle, G.F. Hartlaub, sent a circular to likely parties informing them of an exhibition of contemporary German art he wished to put on. In the event, it was delayed until 1925, but its title, Neue Sachlichkeit, then put this term on the cultural map. Another term bandied about was 'verism', relating to the 'truth to appearances' which was now to be encouraged and which Expressionism had avoided.

Many German artists charted courses between various positions in the

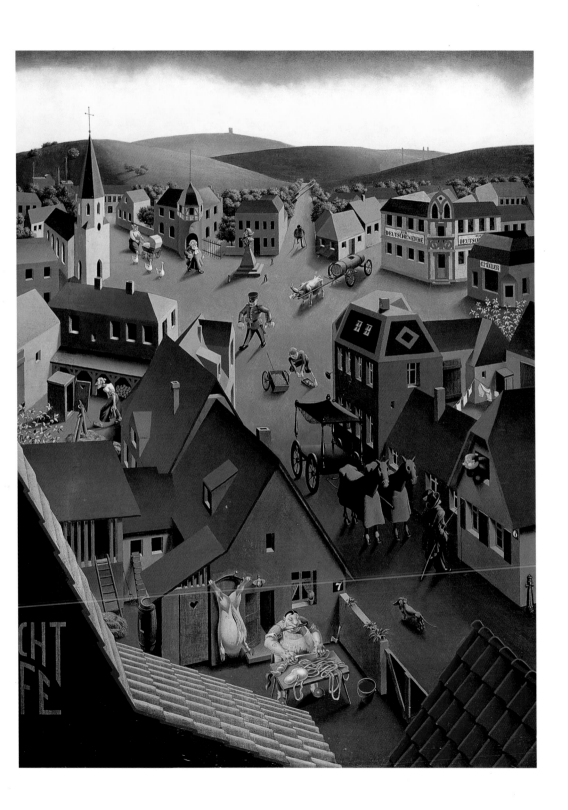

33

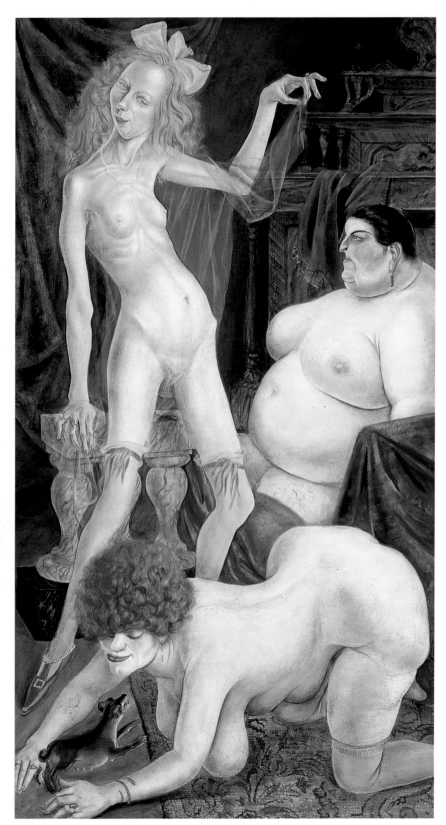

23
Otto Dix

Three Women 1926

Oil on canvas
181 × 105.5
(71¼ × 41½)
Galerie der Stadt
Stuttgart

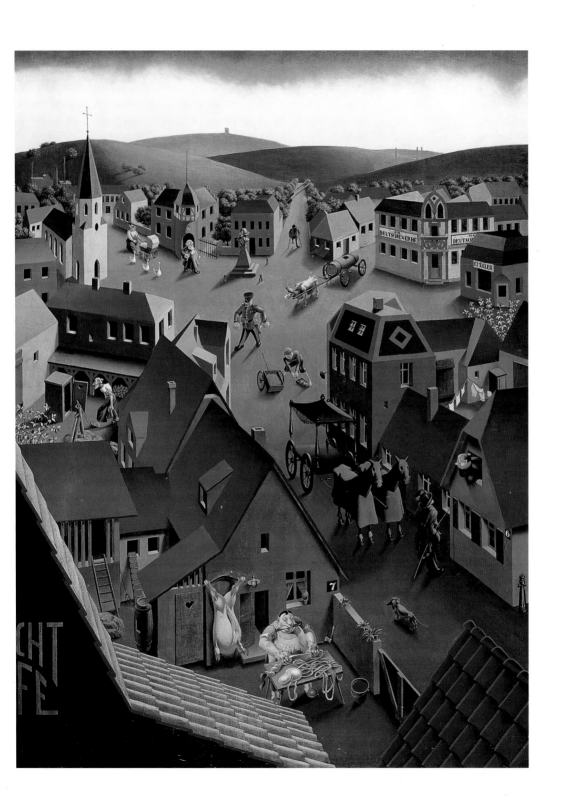

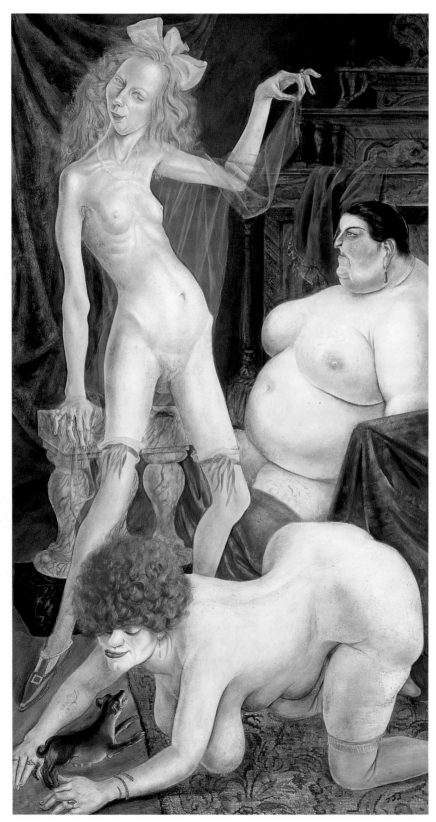

23
Otto Dix

Three Women 1926

Oil on canvas
181 × 105.5
(71¼ × 41½)
Galerie der Stadt
Stuttgart

early, chaotic post-war years: in the late 1920s, once-angry Dadaists like Georg Grosz and Otto Dix often mellowed their vision to mere sardonic reflections on street-life and social turpitude. *A Married Couple* of 1930, a watercolour by Grosz of an elderly couple shuffling along, has overtones of sympathy but also a suggestion of mockery for their smug, blinkered self-absorbtion. The void around them suggests they are oblivious of their surroundings. The old man is probably dreaming of his carpet slippers and a stein of beer, while his wife probably has the ironing to get on with. In his oil paintings Grosz's response to such 'kleinbuerger' (petit-bourgeois) was a ferocious mixture of pity and contempt (his real hatred he kept for army officers, bureaucrats and profiteers); this sketch has the artist's claws sheathed, for the time being. However, these folk of the 'Mittelstand', the 'middling sort', were to be among Hitler's most fervent early supporters.

Georg Scholz was another artist who mellowed in the 1920s; his *Small Town by Day: the Butcher,* of 1922–3, is at first sight enchanting, comparable in its toy-town festive appearance to Spencer's *The Lovers*, where the dustbin men are seen stomping up the Cookham garden paths. Here, similar domesticity is recorded, though a curious sense of unease, even menace, hangs over the view from the rooftops. The striding policeman in his crisp uniform seems too keen on the job and the somnambulistic-looking butcher (who could be the son of Grosz's old man) looks as though he'd not be too fussed at what – or who – he cuts up. The small cart in the middle of the picture belonging to the barefoot boy seems to be borrowed from de Chirico's *Mystery and Melancholy of a Street* (1914) as does the spectral atmosphere around the horse-drawn hearse and the sinister undertaker asking directions of a plump, if nervous Hausfrau: de Chirico's 'metaphysical' paintings, with their downbeat sense of alienation and anguish, had a great impact on the German art scene immediately after the Great War.

The peculiar proclivities of Berlin's nightlife, made familiar to the Anglo-Saxon world by Isherwood's novels (and, much later, over-smoothly by the film 'Cabaret') were captured by Otto Dix's unflattering records of 'working women' such as *Three Women* of 1926, which derives its angular style from Renaissance German artists like Grünewald and Cranach. Rudolf Schlichter, a shoe fetishist, specialised in women wearing tight-fitting boots with high

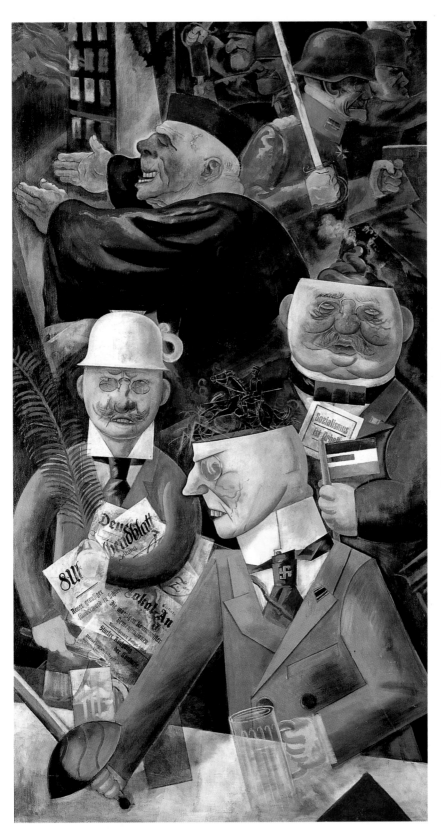

25
George Grosz

Pillars of the Community
1926

Oil on canvas
200 × 108
(78¾ × 42½)
Staatliche Museen zu
Berlin – Preussischer
Kulturbesitz
Nationalgalerie

heels, surrounded by simian-looking clients, as in *Meeting of Fetishists and Maniacal Flagellants* of *c.*1921.

This painting has the sharp social satire of the 1920s. The work of Christian Schad takes a cooler view at the end of the decade with the scarred woman in *Self-Portrait* of 1928. The artist's translucent shirt, useless as a practical garment, reinforces both the nakedness of the angular model (a vivid antithesis to Wesselmann's pneumatic 1960s creature in fig.52) and his own nervous vulnerability. The stylish cropping of the image is a design feature which derives from his lucrative career as book-cover designer.

For Grosz and other haters of authority, the Weimar Republic's failure lay in its connivance with the entrenched positions of the judiciary, the army and the clergy. Indeed, there was no real enthusiasm for the Republic anywhere in a humiliated nation that had been an empire for fifty years and had no previous experience of democratic rule. Biding their time until a favourable moment, the old triumvirate depicted so viciously in Grosz's *Pillars of the Community* of 1926 were at best 'provisional republicans', whose real enthusiasm was reserved for political extremism. They probably did not mourn when the Depression from 1930 and the increasing powerlessness of the government in the face of mass unemployment (six million by 1932) swept the Weimar Republic away. The urban themes of Grosz and Dix were pursued by others. Grosz's fellow 'Objectivist' Gustav Wunderwald described being, in Berlin, 'attracted by the most dreary things, which prey on my mind … with their interesting soberness and wretchedness' and his *Corner* (fig.26) of 1928 is a powerful expression of this response. Others, like Conrad Felixmueller in Dresden found a muted Romanticism in the daily life of the city, as in *Lovers from Dresden*; again the affinities with Spencer's Cookham humility are striking in the clumsy but heartfelt gesture of the couple and the references to the 'old masters' of the German Renaissance, much admired by Felixmueller:

> It has become increasingly clear to me that the only necessary goal is to depict the direct, simple life which one has lived oneself – in the manner in which it was cultivated by the Old Masters.

This could be true of Grosz's old couple as well, who are modern urban descendants of Bruegel's peasants.

Perhaps the most striking realist picture of the period as far as portrayal of a group is concerned is Otto Griebel's *The Internationale* of 1928–30, in which a solid phalanx of representatives from all branches of industry are chanting the song in an airless space. They don't look optimistic, but there is a certain grim force in their features and stance. It is the artist's refusal to heroicise the figures, however, that makes them so different from the Socialist Realism developing in the USSR at this time.

A very different realism was sought by Alexander Kanoldt, in Munich. Known now for the claustrophobic still lifes that reveal an obsession with order, he perhaps felt the weight of history: his father had been one of the last important Nazarenes, that academic-romantic group so influential in nineteenth-century Germany and on the English Pre-Raphaelites. His own training had taken him through Fauve colour and Cubist formalist

disintegrations, to brief membership of the Blue Rider group around Franz Marc and Wassily Kandinsky from whom he broke away in 1911 when he was unable to accept abstraction. Then there is Franz Radziwill, one of the most magical of the Magic Realists: disasters are imminent behind supernaturally lit skies in the bleakly panoramic views Radziwill painstakingly produces, his hallmark being aircraft that swoop like predatory birds (he wanted to be an aircraft designer). In his work, humanity is a numbed victim of approaching cataclysmic forces or, like Grosz's old couple, oblivious to what is signified by the world around. The detail of his paintings and the old-fashioned use of glazes in his technique enhances the doom-laden atmosphere.

The Nazi attitude towards the New Objectivity was dismissive; they preferred the neo-romantic certainties of propagandist 'falsism' to what Frick, Minister of the Interior, attacked in October 1933 as 'the spirit of

26
Gustav Wunderwald

Corner 1928

Oil on canvas
60.5 × 85.5
(23¾ × 33¼)
Staatliche Museen zu
Berlin – Preussischer
Kulturbesitz
Nationalgalerie

27 *right*
Franz Radziwill

Karl Buchstätter's Fatal Dive 1928

Oil on board
90 × 95
(35½ × 37½)
Museum Folkwang,
Essen

28 *below right*
Otto Griebel

The Internationale 1928–30

Oil on canvas
127 × 186
(50 × 73¼)
Deutsches Historiches
Museum, Berlin

subversion . . . those ice-cold, completely un-German constructions'. Hitler, in 1935, condemned the word 'objectivity' itself, though strangely, in connection with 'Dadaist-Cubist and Futurist experience'. Certainly, most of the practitioners of New Objectivity were eased out of official positions by 1935, only those able to exploit such titles as *German Soil* in their works continuing to be tolerated by the regime. Even the tolerated Kanoldt would have his works removed from show in the wake of the 'Degenerate Art' campaign of 1937–8; perhaps because of his historical link to the Blue Rider, *bête noir* for the Nazis, and also because of his rearguard defence of persecuted colleagues. When even Radziwill was expelled from the Nazi party in 1938 Michalski commented: 'Hitler's party unerringly rid itself of its last artist of any importance'.

In many ways, Neue Sachlichkeit aesthetics represented a retreat from the

heels, surrounded by simian-looking clients, as in *Meeting of Fetishists and Maniacal Flagellants* of c.1921.

This painting has the sharp social satire of the 1920s. The work of Christian Schad takes a cooler view at the end of the decade with the scarred woman in *Self-Portrait* of 1928. The artist's translucent shirt, useless as a practical garment, reinforces both the nakedness of the angular model (a vivid antithesis to Wesselmann's pneumatic 1960s creature in fig.52) and his own nervous vulnerability. The stylish cropping of the image is a design feature which derives from his lucrative career as book-cover designer.

For Grosz and other haters of authority, the Weimar Republic's failure lay in its connivance with the entrenched positions of the judiciary, the army and the clergy. Indeed, there was no real enthusiasm for the Republic anywhere in a humiliated nation that had been an empire for fifty years and had no previous experience of democratic rule. Biding their time until a favourable moment, the old triumvirate depicted so viciously in Grosz's *Pillars of the Community* of 1926 were at best 'provisional republicans', whose real enthusiasm was reserved for political extremism. They probably did not mourn when the Depression from 1930 and the increasing powerlessness of the government in the face of mass unemployment (six million by 1932) swept the Weimar Republic away. The urban themes of Grosz and Dix were pursued by others. Grosz's fellow 'Objectivist' Gustav Wunderwald described being, in Berlin, 'attracted by the most dreary things, which prey on my mind … with their interesting soberness and wretchedness' and his *Corner* (fig.26) of 1928 is a powerful expression of this response. Others, like Conrad Felixmueller in Dresden found a muted Romanticism in the daily life of the city, as in *Lovers from Dresden*; again the affinities with Spencer's Cookham humility are striking in the clumsy but heartfelt gesture of the couple and the references to the 'old masters' of the German Renaissance, much admired by Felixmueller:

> It has become increasingly clear to me that the only necessary goal is to depict the direct, simple life which one has lived oneself – in the manner in which it was cultivated by the Old Masters.

This could be true of Grosz's old couple as well, who are modern urban descendants of Bruegel's peasants.

Perhaps the most striking realist picture of the period as far as portrayal of a group is concerned is Otto Griebel's *The Internationale* of 1928–30, in which a solid phalanx of representatives from all branches of industry are chanting the song in an airless space. They don't look optimistic, but there is a certain grim force in their features and stance. It is the artist's refusal to heroicise the figures, however, that makes them so different from the Socialist Realism developing in the USSR at this time.

A very different realism was sought by Alexander Kanoldt, in Munich. Known now for the claustrophobic still lifes that reveal an obsession with order, he perhaps felt the weight of history: his father had been one of the last important Nazarenes, that academic-romantic group so influential in nineteenth-century Germany and on the English Pre-Raphaelites. His own training had taken him through Fauve colour and Cubist formalist

disintegrations, to brief membership of the Blue Rider group around Franz Marc and Wassily Kandinsky from whom he broke away in 1911 when he was unable to accept abstraction. Then there is Franz Radziwill, one of the most magical of the Magic Realists: disasters are imminent behind supernaturally lit skies in the bleakly panoramic views Radziwill painstakingly produces, his hallmark being aircraft that swoop like predatory birds (he wanted to be an aircraft designer). In his work, humanity is a numbed victim of approaching cataclysmic forces or, like Grosz's old couple, oblivious to what is signified by the world around. The detail of his paintings and the old-fashioned use of glazes in his technique enhances the doom-laden atmosphere.

The Nazi attitude towards the New Objectivity was dismissive; they preferred the neo-romantic certainties of propagandist 'falsism' to what Frick, Minister of the Interior, attacked in October 1933 as 'the spirit of

26
Gustav Wunderwald

Corner 1928

Oil on canvas
60.5 × 85.5
(23¾ × 33¾)
Staatliche Museen zu
Berlin – Preussischer
Kulturbesitz
Nationalgalerie

27 *right*
Franz Radziwill

Karl Buchstätter's Fatal Dive 1928

Oil on board
90 × 95
(35½ × 37½)
Museum Folkwang,
Essen

28 *below right*
Otto Griebel

The Internationale
1928–30

Oil on canvas
127 × 186
(50 × 73¼)
Deutsches Historiches
Museum, Berlin

subversion ... those ice-cold, completely un-German constructions'. Hitler, in 1935, condemned the word 'objectivity' itself, though strangely, in connection with 'Dadaist-Cubist and Futurist experience'. Certainly, most of the practitioners of New Objectivity were eased out of official positions by 1935, only those able to exploit such titles as *German Soil* in their works continuing to be tolerated by the regime. Even the tolerated Kanoldt would have his works removed from show in the wake of the 'Degenerate Art' campaign of 1937–8; perhaps because of his historical link to the Blue Rider, *bête noir* for the Nazis, and also because of his rearguard defence of persecuted colleagues. When even Radziwill was expelled from the Nazi party in 1938 Michalski commented: 'Hitler's party unerringly rid itself of its last artist of any importance'.

In many ways, Neue Sachlichkeit aesthetics represented a retreat from the

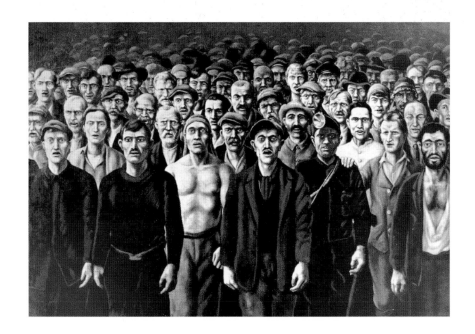

modern world, its machinery and the dispossession of the human that was associated with it. Only in America, at least until 1929, did humanity seem in charge of its destiny. In Europe the First World War had shown the pitiless power of the machine gun and heavy artillery and in the aftermath of the conflict this new relationship of machinery and war seared deeply into the European mind, particularly in defeated Germany. Only totalitarian attitudes seemed able to overcome the prevailing lethargy; in 1930 the critic Wilhelm Michel, a supporter of the New Objectivity, explained its ideological weakness thus:

> From an objective point of view, we have been besieged with too much that is new. Our powers of comprehension have been unable to keep pace with it ... We stand, not in front of machines but rather in front of machine-culture, exactly as if before a war ... without the secure sense of our humanity, forced to make a virtue out of the 'experience' and the observation of details, since we cannot continue to exist as whole ... human beings in the face of the reality rising up all around us.

Fernand Léger apart, it would take the rise of Pop Art and its embracing of the 'brave new world' of consumerism in the late 1950s and 1960s to enable man to co-exist with the machine in anything like an equable relationship.

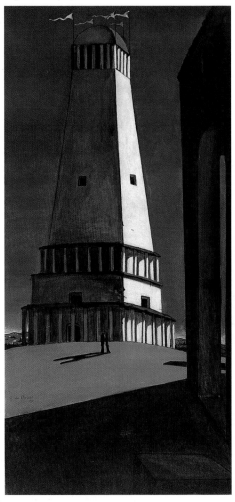

ITALY

Carlo Carrà met Giorgio de Chirico in military life in Ferrara in 1916. They evolved a style, of much influence on Surrealism after the war, which they termed Pittura Metafisica. It evoked the angst of their barracks captivity and sense of powerlessness. They sought certitude – and found it in the Renaissance geometries of the old masters. The result was a determination to recall the calm grandeur of classical art and reinvent it for the post-war world. Their message found acceptance among a number of young Italian artists, with Felice Casorati, Giorgio Morandi (a specialist in still life) and Ubaldo Oppi being the most significant as far as realism is concerned. Another important artist, whose work remained more gestural than these, was Mario Sironi. Loosely gathered around the magazines *Valori Plastici* (*Plastic Values*) and *Novecento* (*Twentieth Century*) they wished fundamentally to reverse the Futurist experiment and embrace the past – what Marinetti, the Futurist leader, had contemptuously described as 'Passeism'. Nevertheless, the cold marmoreal finish to the flesh

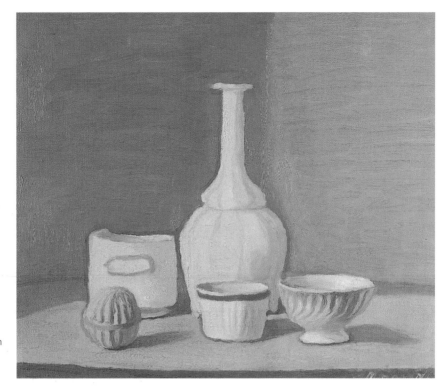

29
Giorgio de Chirico

The Nostalgia of the Infinite ? 1913–14, dated on work 1911

Oil on canvas
135.2 × 64.8
(53¼ × 25½)
The Museum of Modern Art, New York

30
Giorgio Morandi

Still Life 1946

Oil on canvas
37.5 × 45.7
(14¾ × 18)
Tate Gallery

31
Mario Sironi

*Mountains c.*1928

Oil on canvas
81.9 × 107.9
(32¼ × 42½)
Tate Gallery

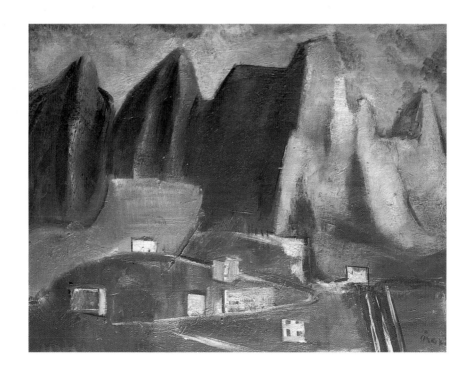

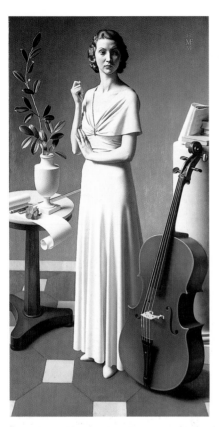

textures and the chilly decor that Casorati in particular utilised, have a machine-tooled element not to be found in Italian painting of the past.

Throughout the 1920s, as Mussolini consolidated power, there was a jostling for influence around the Duce, who had a general interest in art but no desire to meddle. Consequently, considerable freedom of style was afforded Italian artists into the 1930s, when he came increasingly under the influence of Hitler, to his and Italy's detriment. The fanatical quality of national aggrandisement noticeable in German 'Statist' art is largely absent from Italian realist painting, and in this it is closer to the work of a British artist such as Meredith Frampton in the detached and emotionally neutral temperature it prefers. Frampton's *Portrait of a Young Woman* of 1935 might be interchangeable with a Casorati society portrait. Perhaps the lesson here is that it is as false to associate scrupulous illusionistic realism in the 1930s with totalitarianism alone as it is to associate neo-classical architecture in public buildings exclusively with Fascism.

The cold fixity of this Italian imagery was challenged both by abstract art and by the impassioned figurative style of the left-wing artist Renato Guttuso, whose *The Escape from Etna* of 1940 allegorised the foreseeable disaster for Fascist Italy.

32
Meredith Frampton

Portrait of a Young Woman 1935

Oil on canvas
205.7 × 107.9
(81 × 42½)
Tate Gallery

33
Adolf Wissel

Kalenberg Farmer's Family 1939

Oil on canvas
150 × 200
(59 × 78¾)
Oberfinanzdirektion, Munich

PAINTING IN THE THIRD REICH

Under Nazi rule there seemed to be two avenues open to artists looking for subjects that would be approved by the regime. The first, realist only in its illusionist technique, was that of superficial classicism, exemplified in the bombastic posturing of muscle-men allegorising the forces of the new state in the sculpture of Arno Brekker. Even Hitler was allegorised as a knight in armour in H. Lanzinger's *The Flag Bearer*; more usually, he was portrayed full-length in contemporary military uniform as Führer – although he took very seriously his self-appointed role as leader of the nation in aesthetic matters too. Heroic Realism, as the posturing classicistic work of artists such as Brekker might be termed, could occasionally masquerade in contemporary

dress as well, usually for propaganda-poster-like effects as in H.O. Hoyer's *SA Man Rescuing Wounded Comrade in the Street* of 1933.

Art was to pervade every area of national life, demanded the Führer, and the *Great German Art* exhibitions held in Munich even during the later war years were intended to promote this aim. Children's colouring books (there was one called *Soldiers*, for example) were paralleled by academic works called *German Youth*. As well as such promotions of martial spirit, there was endless reiteration of the glories of the good, rural, peasant life, the 'Blood and Soil' connection perhaps not at first having the sinister connotations of self-sacrifice it would later assume. Many city dwellers found this idealisation dull; even the 'characterful' portrayals of *Peasant from Samerberg* or Andri's *Mother and Child* were hardly found more inspiring.

Since National Socialism forbade criticism of the regime and any

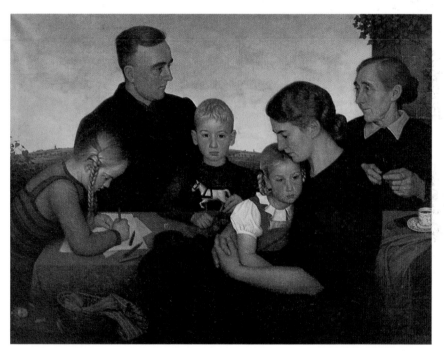

pluralism in the arts, a monolithic uniformity was inevitable. Exhibitions were 'harvests of the artistic will' and artists were seen as aesthetic soldiers. 'Art is a mighty and fanatical mission', declared Hitler, while Goering hoped for an art 'that the ordinary man could understand' (he was busy salting the rest away in Salzburg mines). The ghosts of Cranach, Altdorfer, Dürer and Holbein are evoked in the static linearity and solidly impacted facial features that characterise a supposed return to 'national' roots in painting. One or two works do seem to transcend the narrow party line however, and something of early German Romantic intensity still lingers in Adolf Wissel's *Kalenberg Farmer's Family* of 1939. It lacks dynamism, or even very much interest, but it has a static piety and poise that recalls August Sander's Weimar photographs and Nazarene simplicity. Its technique is faultless and considerably more skilful in its use of glazes than comparable Soviet painting of the same period.

As the war progressed from bad to worse after 1942, German National Socialist realism had to come to terms with defeat. Paintings became more and more exhortatory and fanciful, as with *Hitler at the Front* by E. Scheiber of 1942–3. The Führer seems to enjoy being the centre of devotion of a packed group of soldiers, who would seem to be myopic, so close do they crowd him. This contrasts with the intensely photographic feeling of Paul Mathias Padua's *The Tenth of May 1940*, in which a camera angle on huddled troops paddling across a river on the first morning of the invasion of France is edited so that the captain strikes a pose not far removed from the overstrained gestures of Brekker's Nazi sculpture, only here we are closer to the pages of *Signal*, the Nazi war photography magazine. Yet sections of the picture transcend mere Nazi propaganda. It does have a psychological

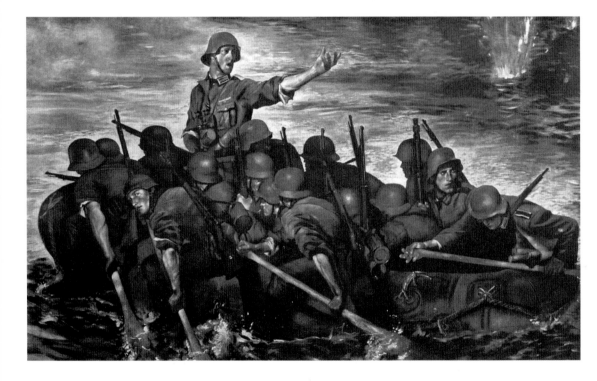

realism about it – after all, heroism is possible – conveyed by the unease of several soldiers under enemy gunfire. The extraordinary glance of one of them, as if into camera, challenges the viewer's security even though the look is curiously difficult to read. On the whole, however, the imagery of Nazi realism remained shallow, like the cultural life of the country, though this is true of most art produced during modern wartime. The state censored the too painful truth (as had occurred in Britain in World War One with Nevinson's war paintings); it might be claimed that after truth, the second casualty in war is realism.

Although much of the work was destroyed in wartime air raids, and the survivors have rarely surfaced from the museum basements, in the late 1970s the legacy of the Third Reich's art produced some uneasy echoes in the

dress as well, usually for propaganda-poster-like effects as in H.O. Hoyer's *SA Man Rescuing Wounded Comrade in the Street* of 1933.

Art was to pervade every area of national life, demanded the Führer, and the *Great German Art* exhibitions held in Munich even during the later war years were intended to promote this aim. Children's colouring books (there was one called *Soldiers,* for example) were paralleled by academic works called *German Youth.* As well as such promotions of martial spirit, there was endless reiteration of the glories of the good, rural, peasant life, the 'Blood and Soil' connection perhaps not at first having the sinister connotations of self-sacrifice it would later assume. Many city dwellers found this idealisation dull; even the 'characterful' portrayals of *Peasant from Samerberg* or Andri's *Mother and Child* were hardly found more inspiring.

Since National Socialism forbade criticism of the regime and any

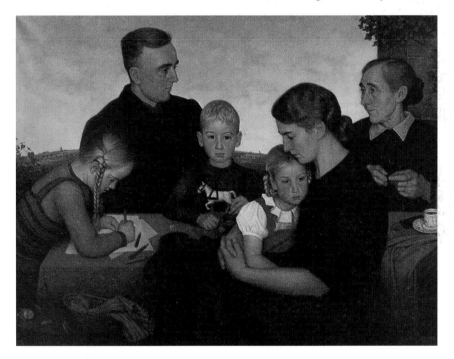

pluralism in the arts, a monolithic uniformity was inevitable. Exhibitions were 'harvests of the artistic will' and artists were seen as aesthetic soldiers. 'Art is a mighty and fanatical mission', declared Hitler, while Goering hoped for an art 'that the ordinary man could understand' (he was busy salting the rest away in Salzburg mines). The ghosts of Cranach, Altdorfer, Dürer and Holbein are evoked in the static linearity and solidly impacted facial features that characterise a supposed return to 'national' roots in painting. One or two works do seem to transcend the narrow party line however, and something of early German Romantic intensity still lingers in Adolf Wissel's *Kalenberg Farmer's Family* of 1939. It lacks dynamism, or even very much interest, but it has a static piety and poise that recalls August Sander's Weimar photographs and Nazarene simplicity. Its technique is faultless and considerably more skilful in its use of glazes than comparable Soviet painting of the same period.

As the war progressed from bad to worse after 1942, German National Socialist realism had to come to terms with defeat. Paintings became more and more exhortatory and fanciful, as with *Hitler at the Front* by E. Scheiber of 1942–3. The Führer seems to enjoy being the centre of devotion of a packed group of soldiers, who would seem to be myopic, so close do they crowd him. This contrasts with the intensely photographic feeling of Paul Mathias Padua's *The Tenth of May 1940*, in which a camera angle on huddled troops paddling across a river on the first morning of the invasion of France is edited so that the captain strikes a pose not far removed from the overstrained gestures of Brekker's Nazi sculpture, only here we are closer to the pages of *Signal*, the Nazi war photography magazine. Yet sections of the picture transcend mere Nazi propaganda. It does have a psychological

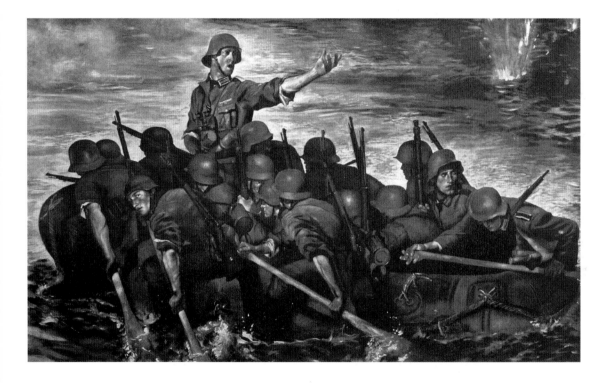

realism about it – after all, heroism is possible – conveyed by the unease of several soldiers under enemy gunfire. The extraordinary glance of one of them, as if into camera, challenges the viewer's security even though the look is curiously difficult to read. On the whole, however, the imagery of Nazi realism remained shallow, like the cultural life of the country, though this is true of most art produced during modern wartime. The state censored the too painful truth (as had occurred in Britain in World War One with Nevinson's war paintings); it might be claimed that after truth, the second casualty in war is realism.

Although much of the work was destroyed in wartime air raids, and the survivors have rarely surfaced from the museum basements, in the late 1970s the legacy of the Third Reich's art produced some uneasy echoes in the

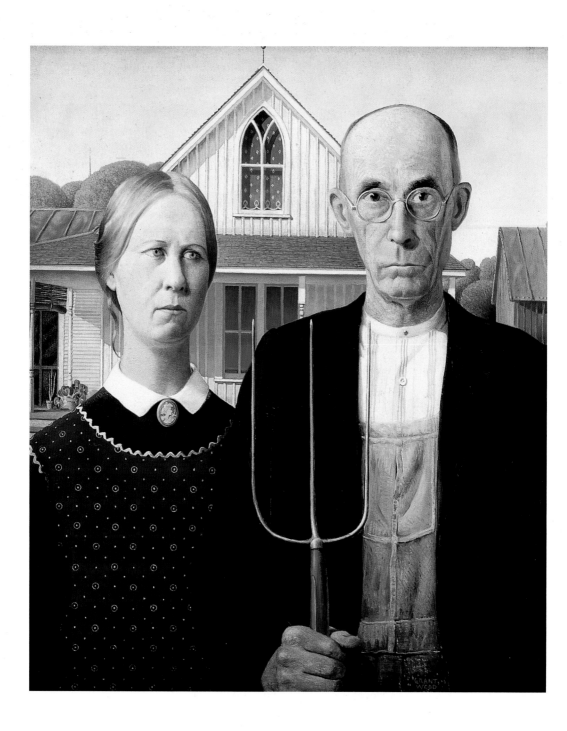

imagery of Anselm Kiefer and Jörg Immendorf. Their realism can be related to that of the 'tendentious' group of Neue Sachlichkeit painters. In the case of Immendorf his work is characterised by distortions which can be spatial, caricatural or reminiscent of comic books, as in the *Cafe Deutschland* cycle he began in 1977. Something of the kaleidoscopic, committed quality of Gunter Grass's novels seems reflected in the magical realism he employs, in which traditional materials are used to portray characters from German history. The symbols are easy enough to read in his work – the German eagle for instance – and the aim is legibility for the political intent of the work, which suggests a revved-up Socialist Realism. It is given a sense of relating to a tradition, however, by a range of references to classic German Expressionist painters like Max Beckmann and Ernst Ludwig Kirchner and so escapes the trap of literalness the Soviet painters were caught in.

More haunting and impressive in their reference back to troubled times are Kiefer's depth-concealing presentations of landscapes or interiors, both appearing equally empty. The pigment is heavy, often loaded with straw, as if to reinforce the reference to nature, and a profound sense of place imbues all his mature work. The interiors, however, are nearer in spirit to the sites of psychic devastation in Francis Bacon than to the 'Blood and Soil' mythology of the Nazis. Yet the latter is what Kiefer often comments on, weaving together guilt, renewal, death, transcendence and the dead weight of history and fact in works both earthbound and suggestive.

34
Paul Mathias Padua
The Tenth of May 1940
Oil on canvas
Dimensions unknown
Private collection

America

America's involvement in the First World War seems to have brought about a revulsion from Europe and European affairs in the two decades that followed. In art this resulted in a strong emphasis on American subject matter and a strong tilt towards forms of realism, away from the experimental avant-gardism that, as in Europe, had exerted its sway in the pre-war years. Of course, avant-garde forms persisted and some notable artists such as Charles Demuth and Charles Sheeler, the so-called Precisionists, combined realist subject matter with a clear-cut geometric style.

One of the most characteristic phenomena of between-the-wars American art was Regionalism. Supported by the critic Thomas Craven, Regionalism nevertheless had no specific style; it was an art that grew from national or local experience, was opposed to dependency on European influence and called for the emergence of an American art. Its leading figures were Thomas Hart Benton, John Steuart Currey and Grant Wood, whose *American Gothic* (fig.35), with its high focus realism and intensity of feeling, is one of the most celebrated of all American paintings.

But perhaps the dominant genius of realist painting in America between the wars was Edward Hopper. As Matthew Baigell (*American Painting*, 1971) has pointed out, Hopper's style is highly traditional but his subject matter is absolutely contemporary. Crucially, however, his subject matter is domestic

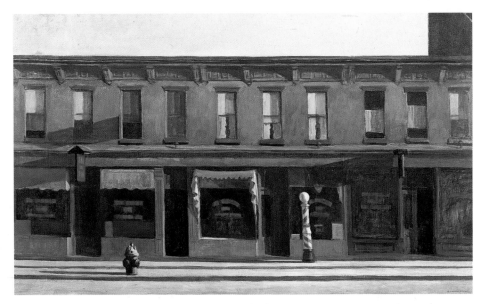

35
Grant Wood

American Gothic 1930

Oil on board
74.3 × 62.4
(29¼ × 24½)
The Art Institute of
Chicago and VAGA New
York, Friends of
American Art Collection

36
Edward Hopper

Early Sunday Morning
1930

Oil on canvas
88.9 × 152.4
(35 × 60)
Collection of Whitney
Museum of American
Art. Purchase, with
funds from Gertrude
Vanderbilt Whitney

and psychological rather than being drawn from the modern industrial scene or modern artefacts. Hopper himself stated that his aim was to make 'the most exact transcription possible of my most intimate impressions of nature'. For Hopper this 'nature' was what he, writing of another artist but equally well describing his own art, described as 'all the sweltering, tawdry life of the American small town, and behind all, the sad desolation of our suburban landscapes'.

THE REALISM OF THE MEXICAN MURALISTS

The Mexican Muralists constitute one of the most intriguing phenomena in twentieth-century painting. In many ways, not least politically, the circumstances of the creation of the industrial murals by Diego Rivera in the early 1930s typify the great dilemma for artists in this period: should ideology be allowed to dictate subject-matter and style, or should the artist trust to his individualism and what might be termed his talent, to comment on or illustrate the ideology? This was a battle lost by the 'individualist' artists both in Germany and Russia at this time, although a few, like Malevich (see p.27), managed to put up a wily, despairing defence for a while.

With Rivera and his followers, the equation is somewhat different. This is partly because Mexico shared the somewhat febrile politics of South America rather than aspiring to the monolithic states of Hitler and Stalin, and also because Rivera produced art in more than one country at just the time when Stalin had advocated the 'socialism in one country' that led to Socialist Realism's sway in Soviet Russia.

It is still remarkable that American capitalists should have been content to employ not merely a radical but a Marxist painter to provide large-scale decorations, in the midst of a hitherto unparalleled economic slump. The

whole question of automated mass-production was causing widespread concern among American unions at the time, but they were cowed by strongarm management tactics, made possible by the economic uncertainties produced by the October 1929 stock market crash.

It is against this background that the Detroit Institute of Arts frescoes depicting the Ford plant at River Rouge, Detroit, painted by Rivera in 1932–3, take on a particular significance. They epitomise the stresses and strains that beset the socially aware artist (as compared to an artist like Matisse, for example). The work consists of twenty-seven panels painted in true fresco, a medium of the Renaissance, which gives an aura of authority to the designs, as well as a mellow matt finish that enhances the cool, distant approach Rivera

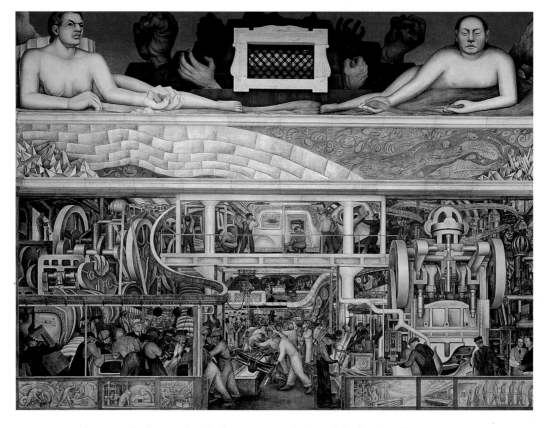

appears to take towards the mechanical processes celebrated in the murals. Indeed, in many images there are atavistic, non-modern elements that are drawn from Rivera's particular national and ancient cultural background. The crouching nude figures, some dark, some pale – but even these with facial characteristics of southern Americans – loom over the scurrying activities of modern workers like ancient deities. This may be part of Rivera's perception, from his Marxist position, that contemporary industry was a destructive juggernaut comparable to the bloodthirsty gods of human sacrifice of preEuropean South American culture. In this light, the works may be seen as warnings to the workers and adjurations to the management. In this it is reminiscent of the naïve plot and moral of Fritz Lang's megalomaniacal

fantasy movie *Metropolis* of 1926, which also reflects concerns about the dehumanising of workforces by factory methods.

It seems clear that Rivera's mature art was shaped by worries about the elitism that avant-gardism appeared to spawn. In Paris as a young Cubist painter connected with Juan Gris, he became disenchanted with the diminishing audience of 'superior persons' that Cubism spoke to. Like Léger, he saw the role of art as to educate the public into new ways of seeing the modern world. This as it might be called 'sense of function' for painting drove him away from easel painting, whose scope for proselytising about 'life and labour and the times' was limited to galleries and private homes, towards a view of 'art as a weapon', a phrase also used by Picasso. Perhaps this idea of painting as a form of attack was why the Marxist Rivera decided to paint works for capitalists like the Rockefellers within their strongholds, rather than simply preaching to the converted. It was a risky business, as Rivera discovered when the Rockefellers obliterated his mural *Man at the Crossroads* because it depicted Lenin. Were the Rockefellers surprised by Lenin's appearance in it? Nevertheless, Rivera did take his work into the enemy camp, as with the mural he did for the luncheon club of the San Francisco Stock Exchange. Rivera's attitude in this case contrasts interestingly with the very different response of the Abstract Expressionist Mark Rothko in the 1950s when he discovered that the space he was making murals for was to become the Four Seasons restaurant. He withdrew his paintings, stating that he did not want his works to be displayed where rich people were gorging themselves. An incident that underlines the ironies of Rivera's position was the purchase in 1931, also by a Rockefeller, of Rivera's sketchbook containing impressions of the 1928 May Day processions in Moscow.

Yet it can also be argued that realism is tempered and reduced in a work 'that depicted clean and well fed workers in apparent harmony with management as well as with the latest technology, producing cars they could scarcely afford, in a plant where production was down to a fifth of pre-1929 levels' (Wood 1993) and where a short while before Rivera's arrival a 3,000-strong Communist-inspired hunger march had resulted in three shot dead and many wounded at the factory gates. The same argument can be used against the squeaky-clean view of Russian worker relations promulgated by Soviet State Realism at the same time, when, as we now know, Collectivism was producing famine and mass starvation in vast areas of the country. In fact, the works of Gerasimov and Rivera alike depict a wished-for state, rather than an actuality: this is a Utopian realism. Nevertheless, these works are not caricatures. Rivera's have the advantage of a freedom of individual response denied to his Russian contemporaries and they are enriched too by their deep-rooted cultural allusions to his Indian heritage. The Russians can look no further back than to various aspects of nineteenth-century bourgeois realism, which they can tentatively annex. Perhaps it can even be argued that the allegorical figures representing birth and the races of the Americas, that hold working humanity in thrall in the Detroit murals, are as 'classic' in a South American way as the less visually convincing ploys of Nazi 'classicistic' works were intended to be under Hitler.

37
Diego Rivera

Detroit Industry 1932–3

Fresco
257.8 × 213.4
(101½ × 84¾)
The Detroit Institute of
Arts. Gift of Edsel B. Ford

4

EUROPEAN AND BRITISH REALISM AFTER 1945

Much European art after 1945 was nurtured by the philosophy of
existentialism, particularly in France. Existentialism's influence saw painters
and writers asserting the responsibility of individuals for their actions and
finding a close relationship between this position and the making of art. Only
by realising their freedom and therefore their responsibility could a person's
life become 'authentic', as opposed to being hostage to a totalitarian force.
The Nazi defendants' cry at Nuremberg that 'Hitler was their conscience'
was the excuse for the abdication of personal responsibility that had led to
the evils of the Nazi regime. Bearing witness to these evils was never going to
be easy. Antonin Artaud, Henri Michaux, Bram van Velde, Giacometti and
Francis Bacon are leading examples of those artists who, immediately after
the war, refused to leave Europe's conscience alone, gnawing at it like a terrier
at a bone. This confrontation was their form of realism, although in strictly
pictorial terms it approached Expressionism. At the other end of the
pendulum swing of the post-war years (until 1956 or so) was a response which
in Britain became known as Neo-Romanticism. This was less realistic than
escapist, perhaps looking to the past and drawing on William Blake and
Samuel Palmer, the dreamier Pre-Raphaelites and the tradition of manual
graphic arts like wood-cutting and engraving. The Neo-Romantics sought to
hearken back to a more innocent, unshattered time, which, of course, had
never existed. John Piper, Graham Sutherland and Paul Nash were the
godfathers of this movement and John Minton, John Craxton and Keith
Vaughan among its leading figures. Like their nineteenth-century Romantic

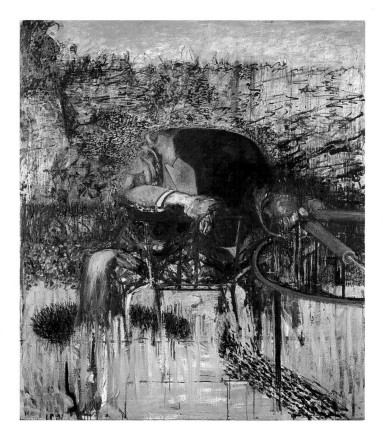

38
Francis Bacon

Figure in a Landscape
1945

Oil on canvas
144.8 × 128.3
(57 × 50½)
Tate Gallery

39
Renato Guttuso

The Discussion
1959–60

Tempera, oil and various
media on canvas
220 × 248
(86½ × 97½)
Tate Gallery

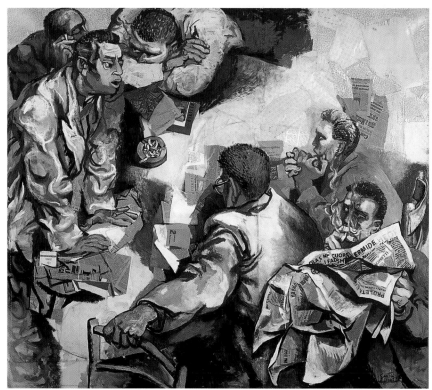

forerunners, they elaborated a stylised, organic shape-shifting, using the 'wiry line' that Blake had praised as the medium of 'energy' which was 'eternal delight'. But throughout, the natural world was a springboard into a poetic fantasy world, rather than an anchorage in the here and now.

A form of realism closer to the tradition of Courbet appeared in Italy in the work of the doctrinaire Communist Renato Guttuso. His crowds of Italian workers and families have a pungent presence and his approach recalls the Italian realist cinema of those years, from Rossi's *Roma, città aperta* through to Visconti's *Rocco and his Brothers*. As will be shown, Lucian Freud developed into the leading British exponent of a realist style at this time.

POP ART IN BRITAIN

By the late 1950s, with consumer culture spreading from America to Western Europe – and to Britain in particular – there was a challenge to the artistic status quo which involved an unprecedented involvement of the art world with popular culture. Material prosperity for a majority of the middle class in Britain, many of whom found themselves with spare money to spend for the first time in their life, led to rapid social change: holidays abroad, the spread of ownership of cars and other 'consumer durables' like televisions and washing machines.

Whereas gadgetry had long been a feature of American daily life, the sheer novelty of such things in most British households gave rise to comment, notably in Richard Hamilton's small but effective collage *Just what is it that makes today's homes so different, so appealing?*, with its title

sounding like the burble of an advertising salesman on television. Hamilton's *$he* makes a similar point. Hamilton was one of the new wave of British artists who created the exhibition *This is Tomorrow* of 1956 at the Whitechapel Art Gallery, a launch pad for their concept of an art based on advertising and other aspects of popular culture and the contemporary urban environment. The term Pop had been coined to describe popular culture itself, being applied to art that was not only based on pop sources but sought to share the characteristics of pop that he and his friends admired. These characteristics included, in a famous list compiled by Hamilton, 'Popular, Transient, Expendable', as well as 'Witty, Sexy, Glamorous'. To many people at the time such qualities, and popular culture itself, seemed despicable, and

utterly alien to art. But in choosing such subject matter the Pop artists were harking back to the approach of Courbet and the nineteenth-century Realists and their British followers such as Sickert who remained much admired in some quarters, especially for his late works based on newspaper photographs. Hamilton's approach mixed a scholarly oil painting method as currently taught in British art schools (he would later teach in one himself) with the collage and photo-montage techniques associated with Dada and Surrealist practice before the Second World War and promulgated in Britain by the exiled Kurt Schwitters and, in the late 1940s, Eduardo Paolozzi. Pop art was a manifestation of social, political and aesthetic revolt whose literary equivalent was the phenomenon of the 'angry young men' led by the playwright John Osborne. Combined with this revolt was nevertheless a desire to make the most of the new affluence. The appearance of Pop Art

40
Richard Hamilton

$he 1959–61

Oil, cellulose paint and collage on wood
121.9×81.3
(48×32)
Tate Gallery

41
Richard Hamilton

Towards a Definitive Statement on the Coming Trends in Men's Wear and Accessories (a) Together Let us Explore the Stars 1962

Oil, cellulose paint and collage on wood
61×81.3
(24×32)
Tate Gallery

coincided with the development of the distinctive youth culture so brilliantly described in Colin MacInnes's novel *Absolute Beginners* of 1958. A separate lifestyle for the young (pop music, coffee bars and scooters at least in the big cities) gave rise to the media concept of the 'generation gap'. Something like full employment meant that the gulf was between the ages of man, not those with jobs and those without.

From this heady period emerged work such as Richard Hamilton's *Towards a Definitive Statement on the Coming Trends in Menswear and Accessories*, its jokey, jaunty manner relaying the fact that 'sex appeal' has become a major feature in such artwork, paralleling the increasing role of sex in advertising, especially in the USA. Peter Blake has been the most consistently realist of the British Pop painters, from his work of the late 1950s to date. In the mid-1970s he even co-founded a group called the Ruralists which sought to restore

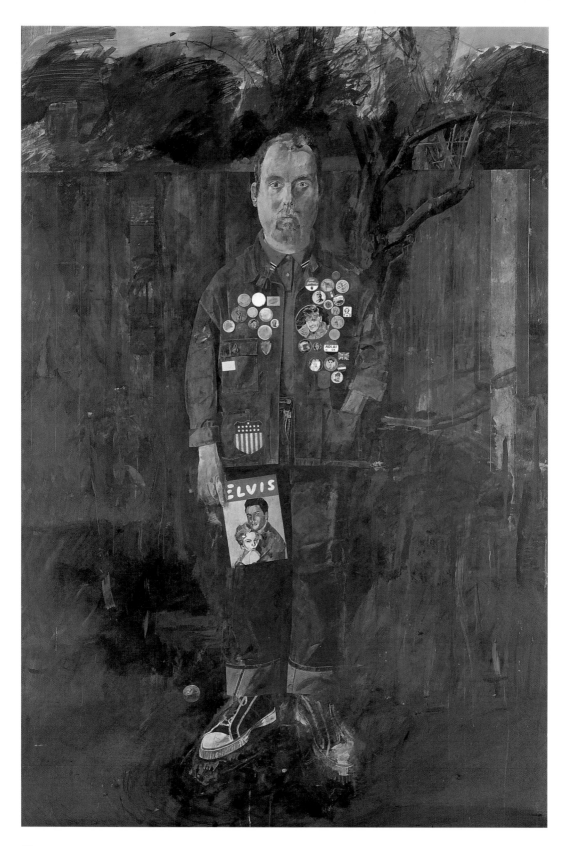

both the spirit and the approach to painting of the Pre-Raphaelites. His *Self-Portrait with Badges* of 1961 blends popular culture (denims and pop music badges) with a style that bows to the Euston Road school. The most prominent badge in this painting refers to Elvis Presley and the work has a comic strip tongue-in-cheek quirkiness as though this pudgy gentleman in denim might transform himself into the superhero singer, who was in fact at the time transforming himself into a pudgy southern gentleman. This poignancy, a certain 'softness', is a special characteristic of Blake's that makes him humanly accessible in a way that American Pop rarely is. His painting methods are manual and homely; the objects he uses are garnered from toyshops, sweetshops and trawls through junkshops that specialise in the relics of childhood.

Blakes's consciousness of the nineteenth-century roots of his work emerges in his art-historical conundrum, *'The Meeting' or 'Have a Nice Day, Mr Hockney'* of 1981–3. This is a camp reworking, under brilliant Californian sun, of Courbet's 1854 portrayal of his meeting with his patron under the southern French sun. The poses in Blake's picture are parodistically close to the original, with Harry Geldzahler, Hockney's leading patron at the time, adopting the slightly hangdog, welcoming gesture of Bruyas in Courbet's image. It is an affectionate parody, however, in its cataloguing of the attractions of California for both artists: the sun, the lightly clad rollerskaters in the background, the typically Blakeian crouching girl in the foreground, who stares out at the viewer, as if at a camera. Her grin reinforces this impression and perhaps underscores the role of photography in the work of

both Blake and Hockney. An easily overlooked surreal touch is the staff the painter is holding: actually a six and a half foot paintbrush.

David Hockney has always resisted being associated with the label Pop Art but his work of the early 1960s does seem inextricably entangled with the phenomenon that was British Pop. His work of that time can however, be called realist only in its subject matter, Hockney's own life and interests as an art student from a northern working-class background discovering himself in London. His style was broad-brushed, graffiti-like, influenced by both Dubuffet and Francis Bacon. But from the mid-1960s, Hockney began to make paintings based on a combination of drawings from life and photographs, either found or, increasingly, taken by himself. Over the next decade he produced a succession of magisterial canvases that must be seen as one of the most significant contributions made anywhere to the continuation of the realist tradition in the late twentieth century.

A Bigger Splash, one of a celebrated group of paintings inspired by California swimming pools, marks the inauguration of this phase of Hockney's career in 1967 and it reached a climax in the late 1960s and early 1970s in his extraordinary series of large double portraits of which *Mr and Mrs Clark and Percy* is probably the best known. The evident realism of these paintings which has brought them such a wide audience is to some extent deceptive. Hockney ruthlessly eliminates superfluous detail and both these

45
David Hockney

Mr and Mrs Clark and Percy 1970–1

Acrylic on canvas
213.4 × 304.8
(84 × 120)
Tate Gallery

44
David Hockney

A Bigger Splash 1967

Acrylic on canvas
242.6 × 243.8
(95½ × 96)
Tate Gallery

paintings have a rigorous linear geometry underlying their composition. *A Bigger Splash* has a wide white border around the main image, whose function is to destroy the spectator's reading of the image as an illusion. This modernist gesture was not repeated but Hockney's realism always pays knowing tribute to the traditions of modern as well as pre-modern art.

REALIST PAINTING IN BRITAIN SINCE 1945

Whereas Pop Art was seduced by the glossy surfaces of magazine advertising and the novelty of domestic colour photography, other realist artists in Britain during this period rejected the flashy and ephemeral elements that made Pop so irritating to the art establishment. A remarkable survivor from an earlier generation was William Roberts, erstwhile member of the avant-garde Vorticist group, formed in London at the outbreak of the First World War, and since the 1920s, depicter of (generally) lighter moments in urban life. His early abstract style gave way to a rather mechanistic figuration which in the post-war years smoothed its surfaces and became ever more tightly structured and controlled. In *Trooping the Colour* (1958–9) the interplay of colours and lines and the placement of the black and red outcrops of the Horse Guards against the orangey background elicits very much the same response that the event itself might: awe at the precision of the organisation, questions about the real nature of the people in the serried ranks (and looking quite toy-like here) and a sense of the geometry and abstraction

latent within the event itself. The portrait of the Queen is sufficiently exact to maintain the sense of reality. It is an astonishing work insofar as it suggests links between Vorticism and Pop Art rarely found elsewhere.

Pure realism continued to surface in the work of Stanley Spencer after the Second World War. In his late self-portrait, done in the year of his death, 1959, a moving sense of mortality pervades the work. The thinness of the paint suggests the urgency of the task but perhaps also reflects a determination, as with many artists at the end of long careers, to pare away anything extraneous and unnecessary. The painting seems to go beyond appearances to reveal the artist's inner life; it has an extraordinary combination of pride and humility.

Many of Lucian Freud's figurative paintings seem to strive for a similar amalgam of seer and modest witness, a combination which gives him a penetrative acuity of vision few twentieth-century artists can rival. This is

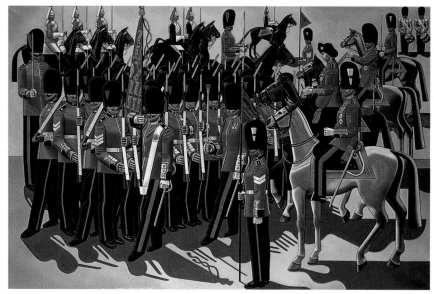

46
William Roberts

Trooping the Colour
1958–9

Oil on canvas
182.9 × 274.3
(72 × 108)
Tate Gallery

47
Stanley Spencer

Self-Portrait 1959

Oil on canvas
50.8 × 40.6
(20 × 16;)
Tate Gallery

combined, however, with an equally powerful quality of detachment. The result is a tension that emerges between the scalpel-like probing of the surface of the bodies presented and a painterliness that leaves out no unbecoming tone, tint or residue, yet never imposes on the figures a meltdown of their humanity as can occur in Francis Bacon's pursuit of 'brutality of fact'. In Freud's portraits of Leigh Bowery in the 1990s, the majestic bulk of the standing figure has a nobility both because of and despite the ravages that the artist perceived and recorded – Bowery died soon after. The spirit of Stanley Spencer's late work infuses that of Freud in recent years, where the realism is manifest in the physical presence of the paint itself rather than as previously through the nature of the poses, for example, *Girl with a White Dog* of 1950–1 where a studio pose endeavours to be natural. Twenty years later, *Naked Portrait,* where the brushes and palette knife replace the redundant hound, has a straightforwardness that is like a blast of fresh air. There is a rawness in the

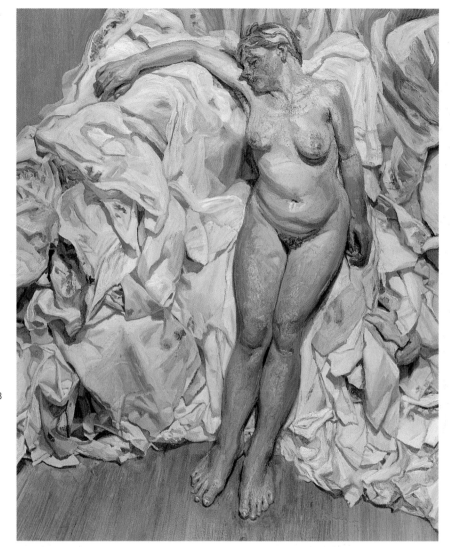

image that derives from the clumsy, explicit nature of the pose, which has a
brutalised element to it, as though the brushes and knife have been, or are
about to be, weapons. Shakespeare's famous phrase from *King Lear*, 'Thou art
nothing but such a bare fork'd animal', comes to mind , although in relation to
Freud the line would have to be delivered with a cold impassivity bordering
on that of the speaking clock, rather than in the tone of passionate avowal
commonly given to it.

The monolithic quality of Lucian Freud's recent work – uncompromising
as an iceberg – is perhaps its most striking and impressive feature. *Standing by the
Rags* of 1988−9 has a warmer tone than in his earlier work to the sagging flesh
of the standing woman whose right arm drapes painfully over the piled white
cloths, but such mellowing doesn't go very far. The tension of her feet gripping
the floorboards in this awkward pose is tangible but, as so often in Freud's
work, no eye contact is established and so what the model might be feeling, if
she is feeling anything (apart from pins and needles), remains unspecified.

5

51
James Rosenquist
F-111 1965
Oil on canvas with
aluminium
304.8 × 2616
(10 × 86 feet)
The Museum of
Modern Art, New York

AMERICAN POP ART AND REALIST PAINTING SINCE 1955

On the whole, Pop Art in America was a more impersonal phenomenon
than the British version. It tended to present reality in such a way that the
object as depicted in the work of art retained an exceptionally close
relationship to the original, as though a very brightly coloured shadow
had been invented.

The reality these artists portrayed was presented to them by the
expanding economy of the United States, its rising standard of living and
super-abundance (for the middle class) of food, goods, entertainment and
time for leisure. In contrast to the academic artists of the time or the artists of
the modernist 'High Art' avant-garde represented by Abstract Expressionism,
the youngsters who followed the Pop route had been trained in commercial
art schools (as Andy Warhol was in Pittsburgh for example). They were also
'realistic' enough to see painting as, first and foremost, a way of earning a
living, and only after that as a form of philosophy. This set them apart
from Rothko, Still, Motherwell, Newman and the coterie around the
influential modernist critics Greenberg and Rosenberg, who seem to have
been surprised, then shocked, then outraged that this new figurative art had
jumped back through the window after the door had been shut on it. By the
end of the 1950s, galleries like Leo Castelli were interested in the new matter-
of-fact style, but critical acclaim was often withheld. 'Welcome figuration,
say goodbye to art', propounded the Abstract Expressionist pundits.

The weapons the American Pop artists could use were their links to the
mass media, both as source material and means of publicity, the accessibility

of the imagery they used and the sense of fun their response to the everyday
world around them engendered, as opposed to the (often unwittingly)
po-faced attitude of the abstractionist 'thinkers'. Television was an
undoubted ally, as had been recognised in Britain too. As Gore Vidal has
noted, things are rarely as bad as they might be on television, nor are they as
good: it levels everything out. Together with Marshall McLuhan's famous
dictum of 1964, 'the medium is the message', this fits in with Pop's ethos very
well. There is nothing transcendent about Pop, in the way that, say, Mark
Rothko intended his work to be. It disclaims individuality and, as did so
many of Andy Warhol's less-is-more statements, this fitted in with the
easy-come, easy-go state of mind advocated by Pop and exemplified in
Warhol's statement 'In the future everyone will be famous for fifteen minutes'.
And when Warhol said that art was 'just a guy's name', he added that he was
as interested in the art of business as he was in the business of art.

Undoubtedly much of this casualness was a pose designed by the Pop
artists to annoy the modernist art critics who had such extraordinary
influence in the contemporaneous New York art world. They succeeded
brilliantly. Tom Wesselmann, James Rosenquist and Warhol himself had all
been commercial artists and this enabled them to treat 'fine' art with a certain
insouciance. Rosenquist had thought his painting of billboards enjoyable
enough to warrant translation into 'fine' art form. In this way he took his
commercial accomplishments, such as being able to control illusionism
sufficiently well that spaghetti painted from three feet away and on a giant

scale would look in focus and in scale when seen from three hundred feet, into the art gallery world.

The salient feature of James Rosenquist's work was his awareness of social stress and strain in the American Dream after the assassination of President Kennedy. What is remarkable is that the flippancy and deliberate short-termism of Pop could, in Rosenquist's hands, transform itself into an icon of the age, a summation of its forces, hopes and fears. This was his *F-111* of 1965. Grandiose though it might be with its four panels, and the eponymous aircraft portrayed as larger than life-size, the work is an astonishing *tour de force*, produced at a time when Pop's enemies were trying to consign Pop Art to the art-historical dustbin. It has a sense of completeness, undisrupted by extraneous elements. The vivid colours cohabit with the echoing shapes: the umbrella and the nuclear explosion, the hairdrier cone over the girl's head, which echoes the nose cone of the aircraft. The result is Pop turned stream-of-consciousness. Rosenquist himself said he wanted to 'accumulate experience' as though the painting might discharge to the viewer a consummate sense of the mid-1960s.

Whereas Rosenquist's exuberant works grew in scale and vivid coloration through the 1960s, this was not the case with Tom Wesselmann, who maintained much closer links with the advertising images he so often plundered and then transmuted in his work. Found objects are sometimes inserted into his paintings, like *trompe l'œil* intrusions from the outside world. They perform the same function as collage did in Picasso's Cubist work of the 'synthetic' period, but Wesselmann's objects are new and shiny, standing for the consumer society. His ironic referencing of tradition is evident in the title *Still Life* given to many works. *Still Life no.12*, for example, has a coke bottle in shallow relief set among illustrations of food from glossy magazines and, like a clue to the source of much Pop imagery, a cut-out of a camera. Names and labels are important to Wesselmann, as to Warhol, but whereas the deliberately clumsy screen-printing of Warhol blunts the impact of the labelling, Wesselmann often gives it a sharp-focused prominence that brings a whole new meaning to 'product placement'. By contrast, the increasingly vague, if pneumatic, forms of his *Great American Nudes* lose all but salient distinguishing features: *Great American Nude no.27*, for example, is reduced to a scrupulously detailed set of lipsticked lips. Otherwise, she is a parody of a Matisse cut-out.

Andy Warhol is one stage away from this approach to reality, drawing attention to the means of making the signs, rather than skilfully disguising them as Wesselmann and Rosenquist tended to do. The crucial phase of Warhol's own run-in with 'reality' characteristically began with money. He attempted to display real dollar bills on a gallery wall but was informed that this was a federal offence, so he produced some clumsily screen-printed versions instead. In fact, the message, that art equals money in the New York gallery world – doesn't seem to have been impaired by this infringement. The world of consumerism, and above all celebrity, seemed to offer Warhol a parallel 'reality' far more glamorous than the one he was lumbered with as the child of Ruthenian emigrants to the States. His whole life turned into the

52
Tom Wesselmann
The Great American Nude no.27 1962
Enamel, casein and collage
121.9 × 91.4
(48 × 36)
The Mayor Gallery, London

53
Andy Warhol

Black Bean (from Soup Can Series I) 1968
Screenprint on paper
88.9 × 58.7
(35 × 23)
Tate Gallery

54
Andy Warhol

Marilyn Diptych 1962
Acrylic on canvas
205.4 × 144.8
(81 × 57)
Tate Gallery

6

SUPERREALISM, PHOTOREALISM AND REALISM IN THE 1980s

What is known as Superrealism or Photorealism is a specifically American and generally urban phenomenon that was the result of a collision between Pop Art's cult of the iconic object – modern, manufactured and, where possible, new and shiny – and photography's equable response to those objects, under a contrived and static light. This sleek, sometimes slick art was also termed New Realism at the time, to differentiate it from the grainy, socially inclined realism of the 1930s (see p.46). By the late 1960s, artists like Richard Estes, Chuck Close, Audrey Flack, Frank Gertsch (who specialised in portraiture) and Charles Bell (who concentrated on still lifes) were making an impact in the New York shows with their still lifes, and irritating the old guard of Abstract Expressionism very greatly. Social commitment was scarcely present in their work; indeed, emotion was expunged, abandoned in favour of a technical virtuosity and dispassion before the object that gives the works a curious 'teflon factor': the eye slips off them, leaving the spectator to clutch at the lifebelt of admiration for technique.

The alternative label of Photorealism is perhaps a more accurate title for a style heavily dependent on new techniques in magazine photography which maximised the sheen and allure demanded by the advertising industry. New techniques, ironically, gave advertisers a mechanical way of achieving on their hoardings what in the early sixties they had employed future Pop artists like Wesselmann and Rosenquist to produce; namely, total identification with the 'product', an illusionism that would beguile consumers into thinking it was already part of 'their' world.

A super-smooth quality dominates the work of the artists named above, giving to the urban landscapes and to the uncanny immobility of the chromed, streamlined vehicles they depict, be they motor-homes or Harley Davidson motorcycles, an often chilly effect. These icons of the later twentieth century, signifying escape and leisure, are here without a price tag, but are betrayed by the stillness of their surroundings. No photorealist work gives the impression of a breeze blowing, which may be why Richard Estes's New York streets are litter-free and anything but 'mean', and not, as he modestly puts it, because 'I can't really get it to look right. It's really a technical deficiency on my part. I really try to make things look dirty,' but it's interesting

55
Audrey Flack
Marilyn 1977
Oil over acrylic on canvas
243.8 × 243.8
(96 × 96)
Collection of the University of Arizona Museum of Art

56
Richard Estes
Movies 1981
Screenprint
50.2 × 69.9
(19¾ x 27½)
Parasol Press

because even in a photograph it doesn't look as dirty as it really is'. But perhaps the real significance of this fascinating remark is that it reveals the extent to which even Photorealism is a long way from reality itself.

Does the fact that it has no 'message' – not even one as relatively mindless as that of Pop Art, mean that Photorealism enshrines mediocrity, as some critics maintain, despite – or because of – its popularity with the public? It lacks the 'fun' element of Pop Art. There is none of the 'sexiness' otherwise endemic in this period. This is perhaps its most remarkable feature. This blank neutrality makes it seem more attuned to the 1990s than the 1960s, except that its proponents lack the ironising distance from the subject itself,

odyssey of an outsider trying to become an insider. In the end, thanks to American society's exuberant mobility, he succeeded beyond his dreams and seemed to become more of an insider than most. By combining his art and his life, he created – at least while the magic held in his lifetime – the sense that the peculiar reality he proposed would indeed supplant the everyday one. A few shrewd psychological tenets helped him (though it was nothing as cogent as a 'philosophy'), mainly concerned with the nature of boredom thresholds and the diminishing returns achieved by the images of horror portrayed in the press and on television. The *Disaster* series of paintings of car accidents is a case in point, later followed by the *Riots* and, most famously, the *Electric Chairs*, in which a grainy photograph of the machine is awash with a single

colour, different in each painting in the series. Warhol imagined that people would choose the colour that would 'go with the drapes'. One could also construct a critique of reality through the repetition undergone in Warhol's paintings of his chosen icons, whether soup cans or Marilyn Monroes. He suggests their equivalence as manufactured objects – in the case of Monroe a product of the Hollywood star machine. Monroe's tragedy was that, unlike the soup, she knew she was being manufactured, but there was no escape. Warhol's fascination with this alternative reality is manifest in his remark, 'I love Hollywood ... Everybody's plastic ... I want to be plastic'. He also wanted to be a machine – they are manufactured too. The converse of this was that Warhol was obsessed by fame, and especially people who were famous

for just being famous. When Warhol moved his peculiarly literal approach to reality beyond painting into film and literature, problems arose. A home movie of 'a whole day in Edie's life' (she was an assistant at the Factory, his studio, where he manufactured his works) or an eight hour sequence focusing on the top of the Empire State Building (*Empire*, 1964), are so stultifyingly dull that they have become cult movies, which is polite avant-garde-speak for the fact that no-one wants to see them. His aim was, indeed, to avoid being 'artistic' or to 'direct' the movies in any way: 'I never liked the idea of picking out certain scenes ... and putting them together, because it ends up being different from what really happened – it's just not like life, it seems so corny'. But in fact his movies are not like life, nor are his paintings, created though they are by screen printing from photo-mechanically made screens using photographic images. Perhaps the painted or silk-screened boxes of Brillo pads and Kelloggs corn flakes, three dimensional objects, come closest to a transcription of reality in Warhol's work. But they aren't 'real' either as Warhol himself knew: 'Everything is sort of artificial. I don't know where the artificial stops and the real starts'.

as well as the challenging conceptual aspect that has emerged in recent 'realism' such as that of the British artist Mark Wallinger. Estes's *Welcome to 42nd Street Victory Theater* in the Detroit Institute of Art is an example: instead of glamour there is glare – which kills off any theatricality. Estes has said: 'I've always considered light to be the real subject of painting' and speaks of giving the 'illusion of light'. This probably accounts for the slipperiness of the objects in his paintings, particularly so in his fascination with mirrored, reflective surfaces such as the one-way glass modishly employed in modern office structures; 'insiders' can see those outside, but not the reverse. As the spectators' eye bounces off the preternaturally gleaming surfaces they are left feeling more like outsiders than ever.

The Photorealists felt that the art establishment side-stepped them. Estes complained: 'The battle for Realist art was not won; it was not even seriously fought'. On the other hand he considered that this allowed the artists concerned 'more of a chance to be themselves'. They believed in the recording of order and form in the exterior world rather than recording any

expression of emotion towards that world. Their aim in this was to create 'a sense of completeness that life itself doesn't have. Order. You take the elements of reality, but you eliminate the chaos'. Yet the establishment of such 'order' may be a dubious, even deadening thing. This detachment would seem to be taken even further in Estes's declaration that: 'I don't enjoy looking at the things I paint, so why should you enjoy it . . . I think I would tear down most of the places I paint'. This is very different from the embattled viewpoint of Neue Sachlichkeit artists such as Otto Dix and Georg Grosz in Weimar Germany.

Something needs to be said about the relationship of Photorealist painting and photography. In photography, the placing of lines and the spaces they enclose are 'givens', instantaneously captured in the photograph. The artist, on the other hand, maintains a choice. Photography is ultimately out of the practitioner's control; Photorealist painting never is. Estes comments darkly: 'unfortunately, it has been too easy for anybody to take a photograph, trace it and make a lousy painting'. Photorealism is perhaps the one realist style that unashamedly admits its direct worship of the veristic old masters, and Vermeer in particular, in praise of whom only Dalí was more hyperbolic. It is also more open in admitting its dependence on the camera, an essential tool even though its results had to be somehow transcended. This openness contrasts with the attitude of, for example, the precisionist painter Charles Sheeler in the 1930s, who denied using photography to structure his painting, even though he had a separate career as a photographer.

57
Robert Longo
National Trust 1981
Cast aluminium,
charcoal and graphite
160 × 594.3
(63 × 234)
Walker Art Center,
Minneapolis

AMERICAN AND BRITISH REALISM POST-POP

In their attitudes to authority and received ideas about history, the German artists discussed in chapter 3 have affinities with two American artists of the 1980s, Robert Longo and Eric Fischl. Longo, in particular, breaks out of conventional strictures of realism while at the same time doing scrupulously modelled and measured work that seems to depend on stills from grainy black-and-white movies. The sprawled figures in *National Trust* (1981) look as if they have been gunned down, linked by the anonymous authority of the aluminium stylised office block that may have been the origin of this denouement.

58
Eric Fischl
Bad Boy 1981
Oil on canvas
167.6 × 243.8
(66 × 96)
Mary Boone Gallery,
New York

This work is concerned with a loss of individual identity that results from corporate culture ruling peoples' lives from a distance. This 'global' influence is also the mainspring of Fischl's tense examinations of responsibility, expressed in a legible, but questioning visual language. Sexuality is the arena he often chooses, as in *Sleepwalker* (1979), where a naked boy in a private garden swimming pool is masturbating, seen by Fischl as a gesture of self-awareness, much as the adolescents in Frank Wedekind's play *Spring Awakening* experienced it eighty years before. Sometimes the scene is more problematic, as in *Bad Boy*. Again the viewer is made voyeur and the scene is set as a play, where a youth confronts a naked woman lying provocatively on a bed, while, shielding it with his body, he is stealing – or at any rate, taking – money from a purse. The filtered rays of light through the drawn blinds make interpretation much harder but adds to the sultry intimacy of the scene; a bowl of fruit and lush bananas nestling

up to the boy irradiate colour but have all the connotations of the forbidden.

In Britain in the 1980s, the figurative current was flowing quite strongly, especially from Scotland. John Keane is one of the most painterly of the new generation of figurative artists and his response to the Gulf War, for which he was the British official war artist, was trenchant and expansive by turns, making use of close connections between social comment and realism, as in his painting of the model of Mickey Mouse in downtown Kuwait City. Subsequently, Peter Howson recorded his experiences in the more muddled world of the Bosnian battlegrounds in 1993–4. His pastels are dispassionate likenesses of, for example, refugees or soldiers on the roads, while the oil paintings derived from them amplify the recollected emotion and make

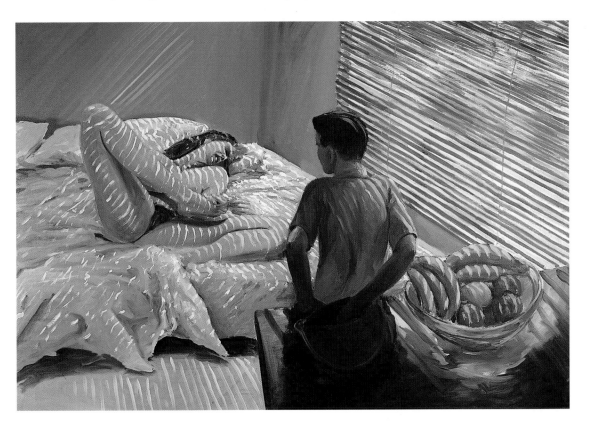

emblems from the casualties, as in *Dog*, depicting a hung animal, huge in the foreground like an icon, rigor mortis in stiffened paint. This scene is transformed through gesticulatory use of paint, and the sheer size and scale of the design. But the hanging was witnessed and the sources from which Howson's images spring are certainly real.

The Saatchi Gallery display *Young British Artists III* in 1994 contained paintings that suggested a Lucian Freud observed through convex mirrors:

59
Jenny Saville

Branded 1992

Oil on canvas
213.4 × 182. 9
(84 × 72)
Saatchi Collection,
London

carefully contrived distortions ballooned parts of the torsos. Another device used by Jenny Saville is to inscribe words onto the flesh of the sitter with the pointed handle of the brush, creating an effect more like graffitti than a tattoo. This technique seems strangely mutilatory and suggests that mere painting of the bodily surface no longer suffices (as it does for Freud). This may be more a sign of a young artist's frustrations with the expressive limits of painting than an advance into new regions of realism.

CONCLUSION

As this brief, by no means conclusive survey suggests, Realism, in the painterly tradition stemming from nineteenth-century British and French art, has all too often been seen as the Cinderella of twentieth-century art, overawed by the glamour of the avant-garde, that concept which gained such power about the year 1910 and held sway until post-modernism's pluralism suggested there might be other, more balanced arrangements of artistic forces.

The description of the work of the Neue Sachlichkeit sub-group, the Magical Realists, as 'poor man's Surrealism' (see p.32) is a case in point, where comparison with an avant-garde proved detrimental. All too often, realism has been its own worst enemy, hoist by its own petard during the ideological decades from the 1920s to the 1950s in particular, as it was co-opted by totalitarian regimes of Left and Right. And yet in America during the Cold War the CIA supported Abstract Expressionism as the 'art of freedom' and the American way, against Soviet Socialist Realism, but because of Abstract Expressionism's claim to intrinsic lofty spiritual and aesthetic ideals it has never been held to blame for such politicking.

The case of Diego Rivera (see p.49) illuminates the would-be realist's problems, faced with what W.B. Yeats, as exasperated theatre director, once termed the 'pragmatical pig of a world'. Yet for all the accusations of selling out or fellow-travelling that were levelled at naïve or wilful painters in the service of various regimes, there were also those who 'told the Truth to Power', including Rivera himself. The darkly brooding presences of Anselm Kiefer's mythopoeic reconstructions of German history in the series of

paintings titled *Germania*, and Gerhard Richter's elision of news photographs and oil painting call into question ways of seeing and how we, as viewers, respond to previously received information in a new guise.

At its best then, realist art is deeply psychological, probing and penetrating the surface of life. The facets which are revealed are as varied as the outlooks of the artists themselves, but only carry conviction when based on the artist's own experience rather than some party line. This is why the ideological art of the totalitarian regimes strikes such a false note, however scrupulous it is to surface appearances. Photorealism suffers from much the same problem; caught up by the sheer thrill of exercising skills of representation, artists like Flack and Estes seem essentially uninterested in any personal presence in their work. It could be done by machines. Perhaps Andy Warhol should have tried being a photorealist for more than fifteen minutes.

This element of the personal in the realist vision subverts the tendency of art historians to present, often for the sake of convenience, realism's practitioners as (admittedly loose-limbed and shambling) groups of artists: rather, on closer inspection, they are seen to be an atomised set of loners, coralled into groups by the collectivising trends of much of this century. Perhaps it can be argued that the more vivid the realist language of the painter, the more individual and the more isolated he or she will appear.

The revival of figurative imagery and of painting itself in the 1980s paralleled the development of a 'cutting edge' agitprop art, whose creators believed that art could influence the external world (after the loss of nerve which followed the Vietnam War). The social person began to count for something again – and the way the individual is manipulated in the West by the forces of government and capital was cannily analysed and exposed in works using photographic, collage and mass-media techniques by Victor Burgin, Barbara Kruger and Jenny Holzer, to name but three. Holzer's sloganeering style and content (for example, 'Protect Me From What I Want' and 'Abuse of Power Comes as No Surprise') puts into words the traumas alluded to and borne witness to by an image like Howson's hung dog (see p.74). Faced with such developments, the notion of 'avant-garde' or 'non-progressive' as labels to be slung round the necks of artists seems at best irrelevant, at worst malign.

Realism may well emerge as a key choice among attitudes and stances available to artists at the start of the new millennium thanks to the previously mentioned pluralism encouraged by the rise of the post-modern viewpoint; one suspects realism flourishes most when the outlook is one of carefully balanced scepticism and activism, in other words, when there's the ability to laugh at something and take it seriously at the same time, however sardonic that laughter.

SELECT BIBLIOGRAPHY

Adam, Peter, *The Arts of the Third Reich*, London 1992.

Cardinal, Robert, *The Landscape Vision of Paul Nash*, London 1989.

Clark, Tim, *The Image of the People*, London 1973.

Clark, Tim, *The Absolute Bourgeois*, London 1973.

Cork, Richard, *A Bitter Truth: Avant-garde Art and the Great War*, London 1994.

Fer, Briony, Batchelor, David and Wood, Paul, *Realism, Rationalism, Surrealism: Art Between the Wars*, New Haven 1993.

Fineberg, Jonathan, *Strategies of Being: Art since 1940*, London 1995.

Harrison, Charles, *Modernism in English Art 1900–1939*, London 1993.

Heller, Robert, *Peter Howson*, Edinburgh 1993.

Kent, Sarah, *Shark-Infested Waters*, London 1995.

Kranzfelder, Ivo, *Edward Hopper*, Cologne 1995.

Maas, Jeremy, *Victorian Painters*, London 1988.

Michalski, Sergiusz, *New Objectivity: Painting, Graphic Art and Photography in Weimar Germany 1919–1933*, Cologne 1993.

Osterwald, Tilman, *Pop Art*, Cologne 1993.

Picon, Gaeton, *Surrealists and Surrealism*, London 1983.

Popple, Kenneth, *Stanley Spencer*, London 1996

Schrader, Bärbel and Schebera, Jürgen, *The 'Golden Twenties': Art and Literature in the Weimar Republic*, New Haven and London 1990.

Stangos, Nikos, *Pictures by David Hockney*, London 1976.

Willett, John, *The New Sobriety: Art and Politics in the Weimar Republic 1917–33*, London 1978.

Wortley, Laura, *A Garden of Bright Images: British Impressionism*, London 1988.

EXHIBITION CATALOGUES

A Paradise Lost: British Neo-Romanticism 1935–55, Barbican Art Gallery, London 1987.

The Last Romantics: The Romantic Tradition in British Art: Burne-Jones to Stanley Spencer, Barbican Art Gallery, London 1989.

Italian Art of the Twentieth Century, Royal Academy, London 1989.

German Art of the Twentieth Century, Royal Academy, London 1985.

American Art of the Twentieth Century, Royal Academy, London 1993.

British Art of the Twentieth Century, Royal Academy, London 1986.

Neue Sachlichkeit and German Realism of the Twenties, Hayward Gallery, London 1978.

On Classic Ground: Picasso, Léger, de Chirico and the New Classicism 1910–1930, Tate Gallery, London 1990.

Frances Morris, *Paris Post War: Art and Existentialism 1945–55*, Tate Gallery, London 1993.

Leslie Parris (ed.), *The Pre-Raphaelites*, Tate Gallery, London 1984.

Frank Whitford et al., *Otto Dix*, Tate Gallery, London 1992.

PHOTOGRAPHIC CREDITS

All photographs are by the Tate Gallery Photographic Department except those listed below.

The publishers have made every effort to trace all the relevant copyright holders and apologise for any omissions that may have been made.

Photo: AKG London 18; Photo: AKG London/Eric Lessing 17; Photo: The University of Arizona Museum of Art, Tuscon, museum purchase with funds provided by the Edward J. Gallagher, Jr. Memorial Fund 55; © Bildarchiv Preussischer Kulturbesitz, Berlin, photo: Jörg P. Anders 1994 and 1977 25, 26; Courtesy Mary Boone Gallery, New York 58; Leo Castelli Photo Archives, New York 51; Photo © 1997 The Art Institute of Chicago. All Rights Reserved 35; Photo © 1997 The Detroit Institute of Arts. Gift of Edsel B. Ford 37; © Museum Folkwang, Essen 27; Giraudon 1; Imperial War Museum 10, 11; Vereinigung der Freunde der Staatlichen Kunsthalle Karlsruhe E.V. 22; The Mayor Gallery, London 52; Metro Pictures 57; Photo © 1996 The Museum of Modern Art, New York 29; Photo: Parasol Press, New York 56; Photo: RMN - H. Lewandowski 2; Saachi Collection, London 59; © VG Bild-Kunst, Bonn 23; © Visual Arts Library, London 34; Weimar Archive G.B. 28, 33; Photo © 1996 Whitney Museum of American Art 36.

COPYRIGHT CREDITS

Works illustrated are copyright as follows:

Balthus, Derain: © ADAGP, Paris and DACS, London 1997

Blake: © Peter Blake 1997 All Rights reserved DACS

De Chirico, Dix, Grosz, Guttuso: © DACS 1997

Spencer (except fig.12, © Tate Gallery): © Estate of Stanley Spencer 1997 All Rights Reserved DACS

Sickert: © Estate of Walter Sickert 1997 All Rights Reserved DACS

Hamilton: © Richard Hamilton 1997 All Rights Reserved DACS

Rosenquist: © James Rosenquist/DACS, London/VAGA, New York 1997

Wesselmann: © Tom Wesselmann/DACS, London/VAGA, New York 1997

Warhol: © ARS, NY and DACS, London 1997

Other works: © The artist or the estate of the artist

INDEX